BARRON'S ART HANDBOOKS

INKS AND WASHES

INKS AND WASHES

BARRON'S

CONTENTS

INK

Ink is a water-soluble medium. This mixture, which can have a thick or thin consistency, can be black, white, or varied in color. From East to West, with important contributions from China and Japan, ink has been used to reproduce texts or for drawing, most commonly on paper.

The Medium

Gallnut, honey, soot, and ashes are some of the materials that were mixed together to make inks, whether they were black, white, or colored. Depending on the place of origin, one or another of these natural media was favored to provide certain qualities and colors to the inks and washes, producing distinctive characteristics to the works of the particular artists.

Ink in the West

Since the Middle Ages, western artists have used inks

White ink was already being used in the fifteenth century. Albrecht Dürer. Praying Hands. Drawing in black and white ink on blue paper. Graphische Sammlung Albertina (Vienna, Austria).

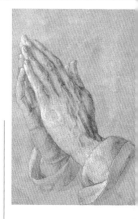

made from gallnuts to make drawings or washes. This type of ink damages the paper and makes it turn yellow with the passage of time.

The oldest India ink (soot, gelatin, and camphor) was used undiluted for both writing and washes. The best examples of this technique can be seen in the work of Dürer and Holbein the Younger.

In terms of color, bistre, a brown ink, was used for ink drawing and washes. Red ink was made from cinnabar, violet was created by mixing cinnabar with indigo, etc.

Ink in the Middle East

Two types of inks were used in the Middle East. The *madad* was a brownish matte ink made from soot and honey, and *ibr*, extracted from gallnuts, was black and glossy.

The Ink Stick in China and Japan

In the Far East, ink is generally made in rectangular bars. The Song formula incorporates powdered pine or cedar ashes

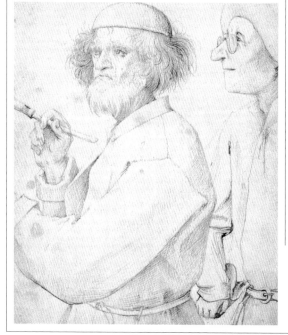

Pieter Brueghel, the Elder. The Painter and the Critic. Pen drawing and bistre ink. Graphische Sammlung Albertina (Vienna, Austria).

"The Four Treasures of the Master's Studio"

In the Far East, the ink stick, the ink stone, the brush, and the brush holder are the four basic tools for painting with ink. Everything that is essential and that surrounds the artist acquires a reverential, almost ceremonial, importance. It is very common for these four treasures to be presented in cases, holders, and delicately adorned containers.

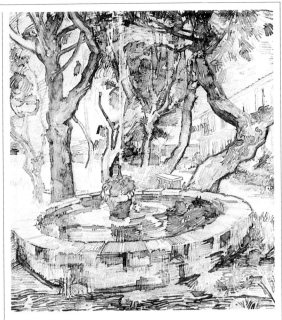

In each period, art has been created following a characteristic technique with the added style of the artist. Vincent van Gogh. The Fountain in the Hospital Garden. *India ink.*

o make a matte ink, whereas he Ming formula uses soot, vhich gives the ink a shiny appearance.

Artists prepare the required mount of ink by rubbing the mall bar with water on an ink tone until the proper consisency is achieved. It has reahed this point when drops of nk acquire an oily appearance nd fall on the stone lowly.

Colored inks, such as azurite blue, malachite green, lead white, dark earth, cinnabar red, indigo, and yellow, are also available in sticks, although they contain glue and are manufactured using hot water.

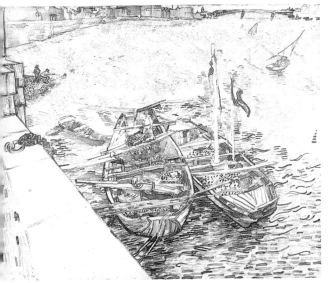

Ink was also used to prepare preliminary studies of large works of art, which were later executed with more elaborate media. Vincent van Gogh. La Crau from Montmajour. *Sienna and sepia ink drawing. British Museum (London, United Kingdom).*

DIP PENS AND FOUNTAIN PENS

Many tools have been used through history to draw with ink, from quill pens, to any type of metal nibs mounted on penholders, to the modern fountain pens.

Quill Pens

Quills are without a doubt one of the oldest tools. The best known is the goose quill, of insuperable quality because of the flexibility and durability of its tip. However, quills from other birds, such as crows or swans, can also be used for ink drawing. The tip of the quill is cut diagonally to be used for drawing.

If the artist desires a more elaborate tip, it can be slit and a hole made between the two sides. This makes it possible to load more ink into the quill, providing a steady supply for doing the work.

The Dip Pen

From the moment dip pens were made available, thanks to writing, an additional tool was incorporated into ink drawing. Metal nibs made their appearance at the end of the eighteenth century, and their inventor gave them his own name, Perry nibs,

Metal pens can be used to draw hatching, which creates a feeling of depth in landscapes.

which is how they are still known today.

From the oldest pens to the most modern ones, there are a variety of types and shapes. But they all consist of two blades with a hole in between, and as with quills, this design allows the ink to flow better. The degree of rigidity or flexibility of the blades determines the result of the drawing.

The Perry nib continues to be the most appropriate one for artistic drawing. Its tip is narrow and flexible, and it is inserted in a wooden holder.

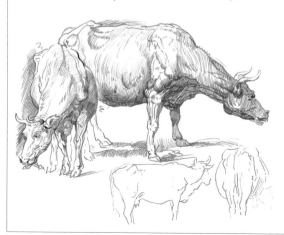

Drawing created with a dip pen in sienna and sepia inks, emulating Peter Paul Rubens. Study of Cows. British Museum (London, United Kingdom).

Dip pen drawing in an English style, known for the labor and mastery required.

A Constant Line Width

Modern technical pens and illustrating tools have rigid nibs. Some are even equipped with a tubular tip and a steady ink supply, but lack the artistic line quality of traditional ink drawings. However, as long as the same tip size is used, the thickness of the line will be consistent. This also applies to fine-point markers.

The Penholder

The nibs are inserted into penholders. This tool is nothing more than a wooden handle in which the nib is held in place by tension. The handle then becomes part of the tool where the hand applies the pressure that extends to the nib, making distinct lines on the paper.

Fountain Pens

Fountain pens, which have an attached nib, work with the ink that is loaded from a bottle or supplied from a prefilled ink reservoir. This way ink does not have to be constantly recharged when it runs out, as is the case with quill pens and dip pens.

These quick sketches were made with a fountain pen and blue ink.

THE REED PEN

It is common, even now, for artists to use a reed for drawing with ink. The works created with a reed have a different and unusual look because it lends itself to different techniques, such as rubbing, making dots and thin or thick lines, and even working with little ink.

A Very Ancient Instrument

Beginning in the eighth century, codices were written and illustrated using reed pens and ink. Later, Dürer also drew with a reed pen, as did van Gogh, Matisse, and others.

Many contemporary artists who have much more sophisticated materials at their disposal still turn to reed pens for certain hatching and scrubbing effects.

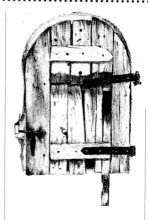

Francesc Llorens is the creator of this old door, drawn with a reed on Schoeller paper and touched up with a dip pen.

MORE ON THIS SUBJECT

- Paper for Dip Pens, Fountain Pens, and Reed Pens **p. 28**
- Diluted Ink, Tones **p. 56**
- Contrast Between Colors and Tones **p. 70**

Always at Hand

For many centuries the reed pen was a very common instrument because artists could easily make their own. Most of them drew from nature, and reeds can be found in many parts of the world. One needs only to cut it and then make whatever tip is needed.

The Slit Nib

To make a slit nib, the artist takes a length of dry and hard reed, cleans it thoroughly, and cuts an angle at one end. This tip is split in two and a hole is pierced through between the two halves. It is similar in shape to the metal nib.

The Angled Nib

Any part of the reed can be used for drawing with ink. However, if a reed is split in half and the tip cut with a bevel, a very sharp point is created that can be used to make fine lines as well as regular ones. At the same time, the artist can employ the entire width of the

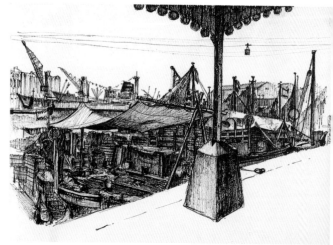

Francesc Llorens. Fishermen's Wharf in Barcelona. Reed pen drawing on Canson paper.

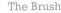

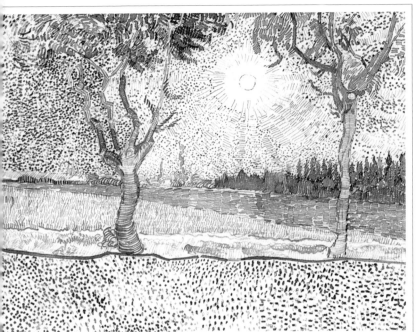

The reed is a tool that can be used to create sketches using various shading techniques. Here, the expressiveness of the lines is clearly representative of the artist's interpretation. Vincent van Gogh. The Road to Tarascon.

nib to make thicker lines. However, the ability of the reed pen with a beveled nib to hold ink is very limited.

The Flexibility of the Point

Its unusual durability makes the reed very useful for certain inking tasks. Compared with the quill the reed is heavier, and it is neither as hard nor as flexible as the dip pen. Lines drawn with a reed pen are unique; they cannot be confused with those drawn with another tool.

In the hands of an artist, the reed becomes the perfect tool for describing shapes and movement using few lines, but with absolute perfection.

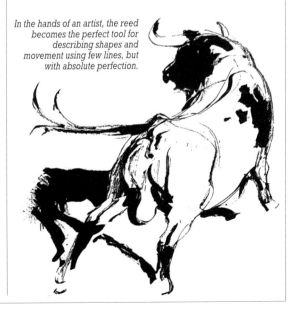

Any Stick Will Do

Any stick, twig, branch, matchstick, or even clothespin can be used the same way as a reed pen. Although they are not exactly the same, it is possible to make lines with wood that resemble those drawn with a reed pen.

THE BRUSH

Together with the quill and the reed, the other traditional tool for ink drawing is the brush. The artistic qualities of the brush depend mainly on the characteristics of the bristles—their shape and the quality of the hair.

A Great Variety

There are many types of brushes for drawing with colored or India ink. They can be made of sable, squirrel hair, and boar's hair, and some Japanese brushes have deer hair.

Each type of brush produces different results, depending on the bristles, from spotting to dry-brushing.

The Japanese Brush

Calligraphy as well as ancient Japanese drawings have been created with a brush. The ink applied with the Japanese brush, whether diluted or undiluted, acquires remarkable characteristics. It is quite a

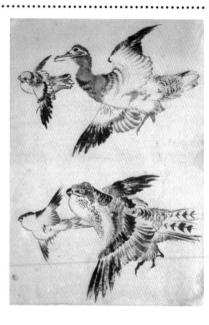

Drawing done with a brush and India ink using the wash technique and yellow ochre watercolors. Katsushika Hokusai. Flying Birds. Galleria degli Uffizi (Florence, Italy).

How to Hold the Japanese Brush

There are three ways of holding the brush: in a vertical position, at an angle, or horizontally. The first position is used to create straight and bold lines, but fine lines can be made as well. The second is for making wide lines, even thick borders, and for covering large surfaces. The horizontal method, holding the brush with the palm of the hand up or down, allows even thicker lines to be made.

In China, art left its mark everywhere, as shown in this beautiful holder for hanging a complete brush collection.

technique, in which different wrist and finger movements are used. The type of ink and the way it is prepared on the ink stone also play a part in the results. The ink flows over the paper or the silk (another traditional support in Japanese and Chinese drawing) in a peculiar way.

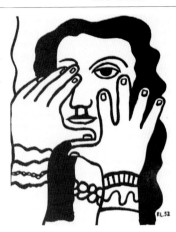

The line can be the protagonist, along with large areas of flat black. Fernand Léger. Face and Hands. Brush and ink over pencil. Museum of Modern Art (New York).

The Flexibility of the Brush

Boar's-hair bristle brushes are without a doubt the least flexible of all. They are used mainly to cover large areas with ink, and with the dry-brush technique to create uniform grays.

The Japanese brush, and all round brushes in general, can produce lines of various widths, from very thin to as wide as the brush can get when the tip is pressed down on the paper.

Leang K'ai. Li Po Reciting a Poem. Brush and ink on paper. Commission for the Protection of Cultural Assets (Tokyo, Japan).

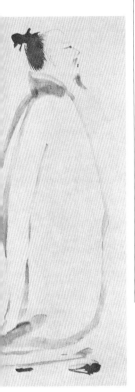

The Versatility of the Brush

Dip pens, even the most flexible ones, are rigid compared with brushes. That is why many artists, including those who draw comics, prefer the brush to dip pens, because it allows them to approach the drawing more freely.

No Hesitating

As soon as the tip of a brush loaded with ink touches the surface of the paper, the mark is permanent. Therefore, it is essential to know how to draw very well. It would probably also help to have practiced several times beforehand to be able to draw a permanent line without making mistakes and without the need for corrections.

Here is a good example of a loose and vibrant line by the great Dutch master Rembrandt van Rijn. Lion Resting. Musée du Louvre (Paris, France).

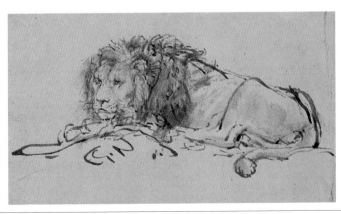

THE WASH

Ink can be used undiluted but also diluted, and in the latter case it is called an ink wash. Because of their similarities, this term is also used to describe monochromatic works or those done with watercolors using only a few colors.

Diluted Ink

Ink can be diluted with water—preferably distilled water. The greater the amount of water used, the lighter the tone of the ink.

Black India ink creates an intense black. A work done with undiluted ink is executed with simple lines because large areas of black make the work very dark. When the artist wishes to reduce the effect of black, the ink is diluted and lighter tones are created. This makes it possible to apply a wide range of grays on the paper.

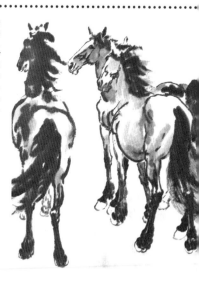

Notice the freshness of the brush strokes, which perfectly express the movement of the horses. Xu Hong. Group of Horses. Fragment.

Mixing Inks

Colored inks can be diluted in the same way as black inks. Two different colored inks can be mixed while they are wet, on the palette and even on the paper itself. With the wet-on-dry technique, mixtures are created by overlaying the colors. But these mixtures begin to look limpid and light when the ink is diluted, since the original colors can be light to begin with. These washes, on white paper, show the beauty of the transparency of inks.

John Constable. Trees Beside the River. Sepia ink. Victoria and Albert Museum (London, United Kingdom).

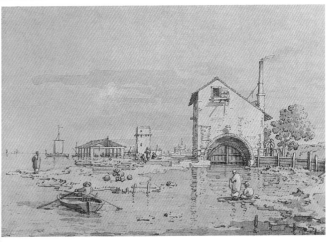

Canaletto. Farmhouse and Tower on the Lake Shore. *Pen and wash with ochre and sienna.* Hermitage (Saint Petersburg, Russia).

The Japanese Sumi-e Wash

In the Far East washes are considered a true painting technique, applied with a brush and using very diluted blocks of paint to give the background a little bit of color. India ink washes created with a brush and representing floral motifs, animals, and landscapes are famous.

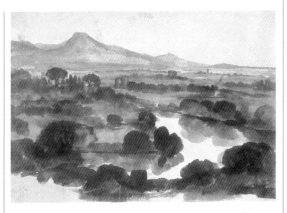

A monochromatic work with a sienna wash representing the Tiber River seen from Mario Mountain in Rome. Claude Lorrain. Landscape with River. *British Museum (London, United Kingdom).*

Do Not Confuse a Wash with an Aquatint

An aquatint is a type of print created with an etching technique (in which acid is used), but with a method that produces halftone effects. A porous ground is used for this purpose that when attacked by the acid forms a grainy surface with a dotted appearance. A range of tones is achieved by superimposing several etched grounds. Francisco Goya was a well-known painter who made works of art using etching techniques.

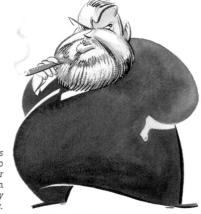

Caricature artists can use washes to add color to their work. Orson Welles *by Alfonso López.*

THE MEDIUM

LINE DRAWING AND POINTILLISM

Fountain pens, technical pens, and fine-point markers, with round or beveled tips, that are used for drafting, for comics, or for advertising illustration can also be used for artistic drawings.

The Line Is the Protagonist

In some drawings, because of their characteristics, the line is absolutely the dominant feature. These are drawings done with an illustrator's pen fitted with a rigid tip or using markers with a fine or chisel tip. Each one of them has a distinctive look because of the character of the lines, in addition to the artistic aspects.

A Constant Line Width

An artistic drawing can also be created using a pen with a tubular tip, typically used for technical drawing. The lines maintain a constant width and intensity, but the intention of the lines is guided by the parameters of the artistic drawing.

Two Line Widths

A rigid nib pen can be used to create fine lines, and heavy ones as well, by simply changing the position of the same

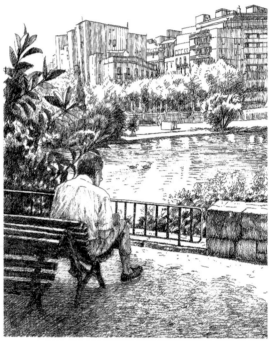

Drawings done with a technical pen are based on superimposing a series of hatching of the same thickness, resulting in crosshatching that models shapes and volumes to create the corresponding light and shadow effects.

pen. This type of pen was used for linear technical drawing until the technical pen made

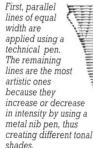

First, parallel lines of equal width are applied using a technical pen. The remaining lines are the most artistic ones because they increase or decrease in intensity by using a metal nib pen, thus creating different tonal shades.

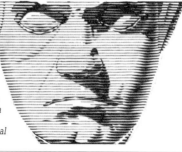

its appearance. The fine lines are used for the light areas, whereas the heavy ones create the areas of shadow. This allows a small tonal range to be developed, enough to give depth to the drawing.

Techniques for Graphic Design

The marker is a basic tool for graphic artists. Because of their immediacy, spectacular sketches can be created very quickly, even faster than with a

Pointillism

It is very common to resort to pointillism to express volume in a drawing. Nearly all artists try this technique for representing the subject matter at some point in their career. The white of the paper is reserved for the areas with most light, and the parts with the greatest density of dots represent the most shaded areas. Total darkness is represented with such a density of dots that the entire area may be covered with them. In addition, there are many variations (the dot can be replaced by a square, etc.). Nowadays, with the availability of computers, there is no reason for anybody to do this type of drawing with a pen. But for the artist, such practice is essential to develop a steady hand and to become proficient at drawing lines.

Using a good-quality smooth paper and a technical pen, the artist can create pointillism as perfect as the one illustrated here.

computer. But markers, used correctly, are also suitable for drawing and painting in full color and for creating both artistic effects and finishes. Each type of marker ink, whether it is alcohol-based or water-based, requires the use of different techniques. Alcohol-based inks are indelible, whereas water-based markers can be treated like watercolors.

MORE ON THIS SUBJECT
• Paper for Dip Pens, Fountain Pens, and Reed Pens **p. 28**
• Complementary Material **p. 36**
• Precautions While Working **p. 44**
• Various Effects **p. 84**

Markers with chisel tips are suitable for graphic design work. The alcohol-based ink, as is the case here, calls for a very special and clean technique to achieve results similar to those of the illustration.

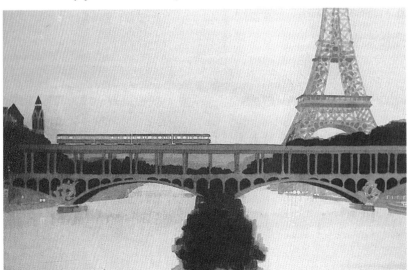

WATERPROOF INK

Inks are available in different compositions and qualities. The first distinction to make is between those that are waterproof and those that are not. Although they are all suitable for writing and doing artwork, the basic difference is their resistance to being diluted after they have dried.

What Is Ink?

Ink sticks, which are prepared for use by diluting in water, or ink in liquid form, are colored solutions that can be used for writing. In other words, a certain amount of ink in the pen should be sufficient to write several consecutive symbols. Gum arabic, which, when treated with an alkali, becomes soluble in water, is usually used as a binder. This is why inks can be diluted with water. These components help the ink flow and make it possible to draw long uninterrupted lines.

Waterproof

Ink is considered to be waterproof when, after being applied to a paper or cloth and drying completely, it does not smear or run when water is added to the lines or areas of color. However, it is possible

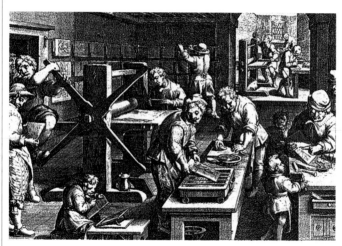

Jan van der Straet, also known as Stradamus. Printmaking shop and printing on copper plates in the sixteenth century.

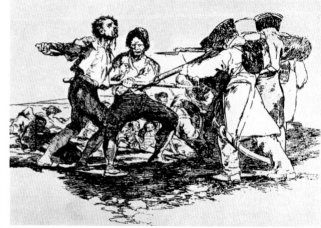

Francisco de Goya y Lucientes. The Disasters of War: with or without reason. Etching. Prado Museum (Madrid, Spain).

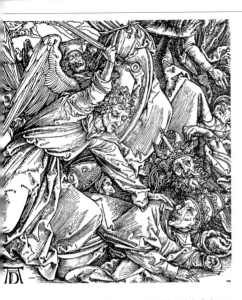

This is the product of a plate etched by *Gérard de Lairesse* for the treatise The Principles of Drawing.

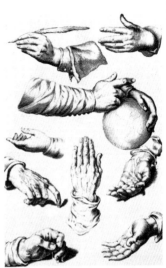

Albretch Dürer. The Four Horsemen of the Apocalypse. *Fragment. Woodcut.*

to thin wet ink by adding water. Inks, because of the fact that they are indelible, are a durable medium when compared with watercolors. The ink that is used in graphic design for printing is waterproof.

Ink Mixtures

Water-soluble inks are similar to watercolors, but the inherent properties of inks, unlike watercolors, make them apt for writing. Very long, fine lines can be made with the ink that is used for artwork. For the same reason, it is suitable for creating consistent, even washes.

The Woodcut and the Etching

Ink is also used in printmaking. Prints made from wood are called woodcuts. Prints made on copper plates using acids, or etchings, are capable of producing halftones and richer work as far as depth is concerned.

Woodcuts as well as etchings facilitate the spread of artwork because the artist is able to make several copies of each print.

The Printing Press and Drawing Lessons

Metal plates allowed a degree of detail that was not achievable with woodcuts, and helped further education by spreading the principles of drawing. High-quality illustrations were printed with metal plates, which could also be accompanied by text.

Emil Nolde. Portrait of an Italian. *Woodcut. Graphische Sammlung Albertina (Vienna, Austria).*

COLORED INKS

Nowadays inks are available in many colors. Although the color selection is not as wide as that of watercolors, inks respond so effectively to mixing that the artist can paint in full color with them.

Color in the Middle Ages

Colored inks were developed by western artists of miniatures as new colors were needed for the filigrees and ornamentation of their manuscripts. The most common colors were red, yellow, blue, green, silver, and gold.

Colored Inks and Printing

Later, color began to be included in prints. Flat colors were characteristic of printed materials. Each plate was coated with the ink only for areas of that particular color. The image was then created by overlaying the impressions from all the plates, one after the other, once the previous one was completely dry.

Colored ink was used for the ornamental filigree of capital letters. Floral letter. Stadbibliothek (Schaffhausen, Switzerland).

Medieval illuminated manuscripts are based on the adornment of the writing with vibrant colors. Martyrology of Usuardo. Museu Diocesà (Girona, Spain).

Colored inks allow the use of the full chromatic spectrum by mixing the colors on the palette or by overlaying them on the paper diluted with water. Drawing by Miquel Ferrón.

Ink Techniques

When painting with colored inks, the same techniques can be used as with watercolors: flat or graded washes, overlaid washes or brush strokes, alternating the techniques of wet on wet and wet on dry. The only difference comes when overlaying inks: if the first layer is completely dry, the second color application will not mix with the first, which remains indelible.

The ideal tool for applying ink using watercolor techniques is the brush. It is quite common for ink drawings to have visible brush strokes, especially when certain types of paper are used as a support. This is because the coloring capability of inks is much greater than that of watercolors, and because of the different degrees of absorption of each type of paper.

Indelible Colored Inks

Some colored inks are indelible. Other inks, however, are very similar to watercolors. The only difference is that they can be used for writing, using dip pens or fountain pens.

To make sure that a colored ink for which there is not much information is indeed waterproof, simply submerge a sample in water. It is indelible if after this test the ink does not run or alter in any way.

To see if a colored ink is indelible, simply submerge a piece of paper with a sample of the completely dry ink in a dish of water.

AIRBRUSH PAINTING

The use of the airbrush is very recent. It reached its peak in the twentieth century, well into the 1980s. This technique, despite being labor intensive and complicated, produces high-quality, precision work.

Airbrush Inks or Anilines

The inks used in the airbrush technique are known as anilines. Airbrush inks or anilines are liquid watercolors, but with a great luminosity.

In general, work created with the airbrush is usually finished with details done with colored pencils, markers, and acrylic paints.

Gradations and Variegated Effects

The artist may choose to apply a flat layer of paint with the airbrush. But it is also possible to paint a subtle gradation without skipping any tonal values, or even a very clean variegated gradation. This can be done if the paint is sprayed at low pressure and the tip of the airbrush is opened to the maximum. Wide fans of color are created in this way. By spraying over one particular area more than another, various tonal values of the same color are created. Two-color graded washes over variegated backgrounds can be made by overlaying applications of different colors.

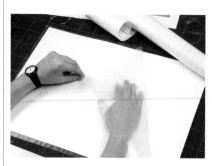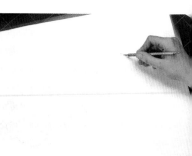

The detailed sketch is covered with an adhesive mask, which is cut out with a utility knife wherever a specific detail is to be painted with a particular color.

Spraying Liquid Color

The simplest airbrush is the one that can spray a stream of color that is always the same width. The independent double-action airbrush, the most common one, allows control of air pressure, color flow, and the size of the ink jet with a double-action switch that regulates the interior mechanism.

Masking and Templates

The techniques for applying paint with the airbrush are based on the use of adhesive masks that cover the areas that are not intended to receive any paint. For this, a special self-adhesive film is used to completely cover the parts of the support where the artist has previously laid out a detailed sketch with clear, concise lines. Then, with the help of a utility knife, the film is cut out to produce the pattern that will preserve the areas that are to be left unpainted. The film for making stencils is transparent, and its special adhesive makes

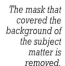

The mask that covered the background of the subject matter is removed.

The mask completely protects the paper from the applications of several colors.

In this work, Myriam Ferrón has created a contrast effect dictated by the requirements of an advertising assignment.

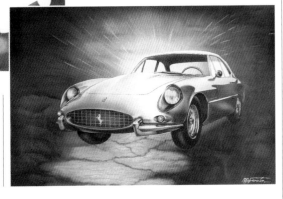

t possible to place and remove he stencils easily. By removing or replacing the masking hat corresponds to each detail, it can be painted with or protected from other colors.

The Computer

Nowadays, an effect similar to that of airbrushing can be achieved directly with painting and drawing computer programs. The difference lies in the support for the painting: a virtual one for audiovisual media, or printed on paper in four colors.

Using the tools of certain computer programs that mimic the effects of an airbrush, the artist can obtain results that emulate a photograph with special lighting effects.

MORE ON THIS SUBJECT

- Colored Inks **p. 20**
- Paper for Washes **p. 30**
- Diluted Ink, Tones **p. 56**
- Color Theory for Ink **p. 62**

Creating Contrast with the Airbrush

The outlines are sharp and create such a distinctive contrast with the background that the forms become very dramatic. The desired degree of contrast can be controlled by applying light colors first and then, progressively, the dark ones.

Using an airbrush is a practical means of illustrating the blurring that suggests speed. Drawing by Miquel Ferrón.

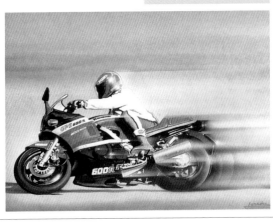

DIP PENS, FOUNTAIN PENS, AND REED PENS

Nowadays, the most common tools for drawing with ink are dip pens, fountain pens with a steady flow of ink, and reed pens. Although dip pens are no longer popular, those that are still around in various shapes are the ones being used for artwork.

Calligraphy with Dip Pens

Fine-point markers and ballpoint pens are generally chosen over dip and fountain pens. Few are the schools that continue to use dip pens for calligraphy. Yet, this is a great method for training the hand and practicing with ink.

Charging the Pen

Dip pens must be charged with ink (by dipping the nib in the inkwell) every time they run out. On one hand, this creates more work, and on the other, it causes the line to vary in intensity. With less ink, the lines become lighter.

Fountain pens are equipped with a prefilled ink cartridge. Whether they have a nib tip or a round tube, they provide a steady, even flow of ink out of the pen down to the nib or tip.

Markers also have an ink reservoir connected to the felt tip. When using a ballpoint or roller ball, the ink is dispensed by the rotation of the tip's ball.

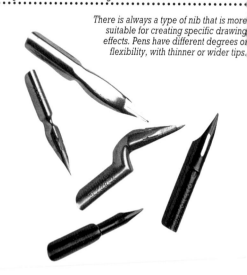

There is always a type of nib that is more suitable for creating specific drawing effects. Pens have different degrees of flexibility, with thinner or wider tips.

Reed Pens

The most durable pens are made of bamboo. They can be found in art supply stores in various shapes and forms.

MORE ON THIS SUBJECT

- Ink **p. 6**
- Dip Pens and Fountain Pens **p. 8**
- The Reed Pen **p. 10**
- Paper for Dip Pens, Fountain Pens, and Reed Pens **p. 28**

They all have a split tip, which is used for drawing. In addition, some reed pens have a tip cut at an angle on the opposite end, which is used to cover large surfaces by keeping the wide, angled tip flat on the paper.

It is a good idea to clean the reed pen after each project. It is sufficient to rinse it with clean water and then dry it with a cotton rag or with a piece of paper towel. Care should be taken not to leave traces of dry

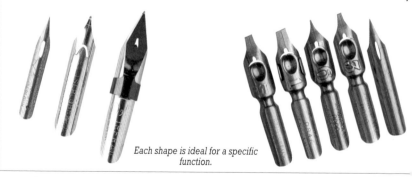

Each shape is ideal for a specific function.

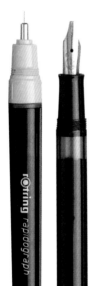

The technical pen with a tubular nib and the conventional fountain pen for writing are also used for artistic drawing with ink.

The dip pen is washed thoroughly with water and then dried.

nk or it will have to be re-moved by scraping the dirty areas of the reed carefully with a utility knife or a piece of fine-grit sandpaper.

The Reed Pen Is Easy to Make

For many years, the artists who drew and painted outdoors used reed pens (a material that was readily available anywhere they went) as tools for studies and sketches. Cutting the tip at an angle is relatively easy. Making a reed that is properly split requires a little more effort.

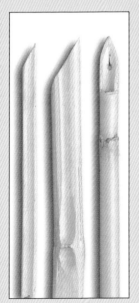

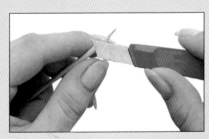

It is easy to cut the tip of a reed at an angle.

A reed can be transformed into a pen for drawing with ink by splitting it with a utility knife, imitating the metal nib of a dip pen.

Samples of different types of reed pens that can be made easily.

BRUSHES

Brushes are required for washes and are greatly valued for their brush stroke in all wet drawing techniques. Some brushes, depending on their shape and quality, are more suitable than others for their specific artistic applications.

The Brush

Basically, a brush consists of bristles, a handle, and normally a metal ferrule that attaches the hair to the handle. In many Japanese brushes the bristles are directly crimped into the bamboo handle. Other brushes require a piece that works as a ferrule, especially when the brush is very thick, which would also require a very thick handle.

A wide variety of brushes is available, including flat synthetic brushes, round ones made of ox hair, and fine sable-hair brushes.

The Quality

The quality of the brush depends, above all, on the type of hair the bristles are made of. Sable-hair brushes are sought after because of their softness and flexibility. The equivalent, deer hair, is used in Japanese brushes and has the same characteristics. There are also hog-hair brushes and synthetic ones, which are much stiffer. The Japanese brushes made of boar's hair are the least flexible.

The Shape

The shape of the brush is, without a doubt, another important characteristic. Round, thick brushes hold a lot of ink and can cover large areas. A fitch brush, which holds less

The brush, thoroughly cleaned, is left to dry with the bristles facing up so they do not become splayed.

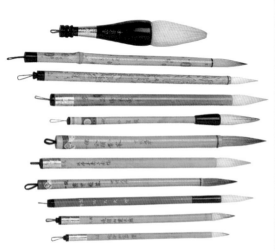

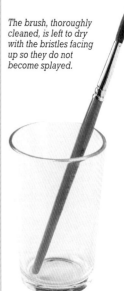

There are many variations within the range of Oriental brushes (or fude). The handle is made of bamboo, and the bristles consist of soft deer hair, or boar's hair if the artist requires them to be stiffer. There is always a specific brush for a particular decorative need.

A fitch brush is used to apply very wide areas of paint and to cover a large surface of the paper.

ers are designed to hang the brushes with the tip down. After the brush has dried, it will have kept its shape and will be ready for a new session.

paint, is also used to cover large surfaces. The thinner the brush, or the lower its number, the finer the brush stroke that can be made with it.

Caring for the Brush

Ink brushes are cleaned by rinsing them with running tap water soon after they are used. Then they are left to dry with the bristles facing up, making sure the hair is properly shaped. Japanese brush hold-

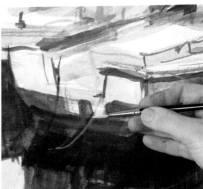

Thin brushes are used for very fine lines and details.

The Double-Bristle Brush

Brushes made with double bristles are very useful because of their unique brush stroke. The double bristle consists of a single bunch of thick hair attached to the handle at the ferrule. The hair on this brush becomes thinner as it approaches the tip, which is formed of only a few bristles. Therefore, a double-bristle brush holds a great amount of ink but the fine tip draws narrow lines that are intense and consistent for an extended period of time.

Double-bristle brushes hold a large amount of ink, but at the same time they make it possible to draw very fine lines.

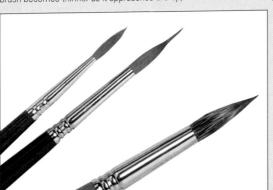

PAPER FOR DIP PENS, FOUNTAIN PENS, AND REED PENS

The paper that is usually employed as a support for dip pens, fountain pens, and reed pens must allow the point of the tool to glide smoothly over it, and the ink to adhere properly or to penetrate, while not being too absorbent.

• •

For Drawing with Ink

Not every paper is suitable for drawing with ink. A paper on which the ink, once it has dried, can be removed by simply scratching with a fingernail is not good. The paper should not have so much texture that it makes drawing on it difficult or impossible. The tip of the pen, whether a quill, nib, or reed, should glide over the surface with ease. A paper that is too soft or too absorbent will soak up too much ink, and whenever the pen stops at a point, it will make a large blotch that becomes bigger as the paper absorbs the ink.

The best paper for ink drawings is smooth paper. It should have enough body so the nib will not scratch it when drawing. Other special papers, such as vellum, parchment paper, or mylar, more suitable

The most suitable paper for drawing with dip pens, fountain pens, and reed pens is a smooth paper, which has enough body to prevent the pen from scratching the surface.

for technical work, are also good for ink.

For Reed Pens

The reed pen is a tool that basically draws by creating friction on the paper. It is not uncommon to favor textured papers for use with this tool, because they not only enhance the friction but also give the drawings created with these pens an even more unique stamp, if possible, making them look as if they were scraped or rubbed.

If the paper is too absorbent, it will absorb a lot of ink when the pen stops at a particular point. The longer the pen stays at that point, the larger the blotch of ink will become.

Always Test the Paper

There are many serviceable papers made by different manufacturers. Other papers

Reed pens produce good results on textured papers, which provide good friction and promote the adhesion of the ink.

Portfolios

Portfolios are used for temporarily storing ink drawings and for carrying them. A sheet of tissue or tracing paper should be placed over each drawing for protection. It also helps protect the work when it must be handled, so the fingers touch only the back of the paper.

The portfolio should be larger than the work that is stored in it. It is a good idea to have an assortment of portfolios of different sizes to hold all types of work.

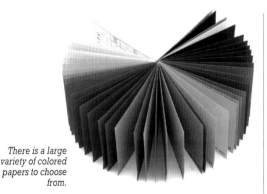

There is a large variety of colored papers to choose from.

It is also important to experiment with the absorbency of the paper by letting a drop of ink fall. If it spreads quickly, it indicates that this type of paper will not favor corrections by scratching.

Colored Papers

Colored papers can be a good support for ink applied with dip pens, fountain pens, and reed pens. The artist should make sure that the pen glides smoothly over the surface and that the absorbency of the paper is adequate.

that may be suitable for different techniques, such as drawing and sketching, may also be appropriate for drawing with ink. The artist should always test a new paper before using it with ink. It is the only way to find out if the dip pen, fountain pen, or reed pen will move smoothly on the surface.

The dip pen, fountain pen, and reed pen work very well on smooth papers: (a) quill pen; (b) reed pen; (c) dip pen.

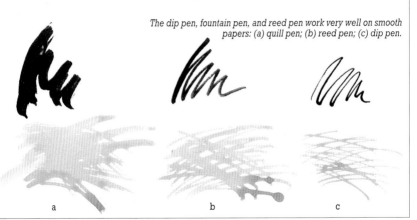

a b c

PAPER FOR WASHES

For painting with washes, it is necessary to use a paper that can withstand water but at the same time is not excessively absorbent. In practice, the same papers that are good for watercolors are suitable for washes. If rice paper is used, a felt is required to soak up the water.

Watercolor Papers

All watercolor papers are suitable for use with washes. A good watercolor paper is usually heavy, and it is meant for work that involves a lot of water and large washes. It is not necessary to use such a heavy paper for light washes. However, the artist should always test a lighter paper beforehand to make sure it does not buckle from the wash or the dampness of the ink itself.

From left to right: fine-grain watercolor paper, heavy-grain watercolor paper, and coated paper that will withstand scraping.

When beginning a drawing with washes, the artist must plan the stages of the project and decide whether additional tools, other than brushes, are going to be used. If this is the case, a smoother paper should be chosen.

The Effects of Texture

Grain is classified as fine, medium, and heavy. Every brand of paper has its own

Other finer papers also withstand light washes and are more suitable for combining the wash technique applied with a brush with the line technique done with a dip pen, fountain pen, and reed pen.

The Grain of the Paper

When working with a brush, a wash looks good on a grained watercolor paper. The diluted ink can also be applied with a reed pen. On the other hand, it is more difficult to use dip and fountain pens with diluted ink on this type of surface.

There are special papers, like rice paper, tissue paper, and recycled paper.

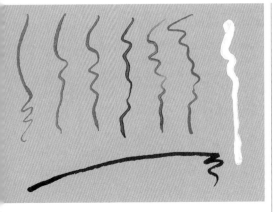

The ink wash should stand out from the color of the paper being used.

of washes applied with a brush and lines made with a dip or fountain pen.

There are other papers, such as *fancy silk*, rice paper, or recycled paper, that can be used with ink washes to obtain artistic results.

MORE ON THIS SUBJECT

· Diluted Ink, Tones **p. 56**
· Gradation Techniques **p. 60**
· Contrast Between Colors and Tones **p. 70**
· Overlaying Washes **p. 76**
· Variegated and Graded Washes **p. 78**

grain design. This design becomes more visible with the luminous quality of the colored inks used for washes, and provides a specific texture.

Special Papers

Colored papers made for use with pastels are suitable for very light washes. The hues of the inks used for the washes must be able to stand out against the color of the paper. One side of these papers is heavily textured and the other is smoother. The smooth side should be used when the project includes a combination

An appropriate paper, neither too porous nor too smooth, provides good results with all the drawing instruments. From left to right: quill pen, reed pen, three types of metal nibs, and the brush.

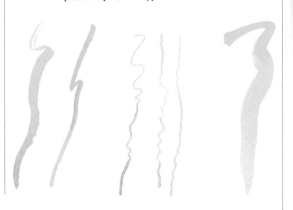

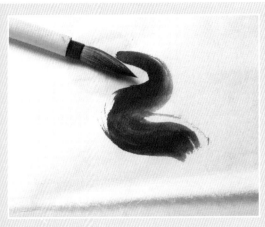

Rice Paper

Rice paper is the traditional support for Japanese washes. This paper does not have much sizing and it is very absorbent. It is normally used with a felt underneath to help absorb the excess water from the wash.

Sample of an ink brush stroke on rice paper, which is commonly used for Japanese washes.

SUPPORTS, MATERIALS, AND TOOLS

OTHER SUPPORTS

Paper is not the only support for drawing with ink. Silk is another traditional base. But there are other suitable surfaces, too, including other fabrics. The only requirement for the surfaces of these alternative supports is that they hold the ink once it has dried.

Silk

Ink washes on silk are traditional in Chinese and Japanese cultures. Silk is used as a support to adorn religious texts, and for ceremonial purposes because of its shiny finish. However, we must not forget that silk is the material of choice for traditional costumes and other garments, as well as for true works of art.

Silk is ideal for ink washes because its point of absorbency allows the wash or brush stroke to remain perfectly intact once the ink has dried.

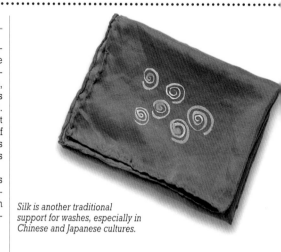

Silk is another traditional support for washes, especially in Chinese and Japanese cultures.

Primed Fabrics

Fabrics that are already prepared or primed for oil or acrylic painting are good supports for ink, whether it is applied with a dip, reed, or fountain pen. For dip and fountain pens it is better to use a fine texture, whereas for reed pens, on the other hand, a wide-weave fabric is more suitable. In terms of washes, the absorption capability of this type of fabric is low; therefore, it is better to work with very flat fabrics so no unwanted marks occur. Because of the lack of absorption, undiluted washes and inks dry through water evaporation at a slow rate.

A canvas primed for use with oil paints whether fine textured or of a wider weave makes a good support for ink drawings or washes.

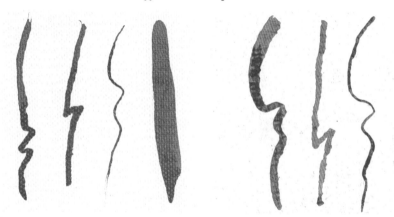

Other Less Common Surfaces

Certain plastic or metal surfaces are not recommended, because simply rubbing the ink will cause it to come off easily when it is dry. But because there are so many different materials available, it is worth experimenting with them, because some polymers, polyesters, or galvanized surfaces do retain ink.

Certain plastic or similar surfaces, as well as enameled metals, may also hold ink well.

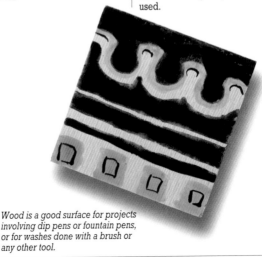

Ink can be used on natural, unprimed fabrics.

Other Fabrics

Linen, burlap, cotton, and absorbent fabrics can all be used as supports for work with ink and washes. The quality they have in common is that they are natural materials. As for man-made fabrics, they should be tested first to assess the behavior of the ink.

These fabrics are very absorbent because they have not been previously treated with any type of primer, and their surfaces are not suitable for dip and fountain pens. The strokes of a brush and of the reed pen bleed because of the fabric's great absorption capability. The brush strokes look heavy and provide a very distinctive appearance to the drawing.

Wood

Wood surfaces that are not varnished are also a good support for ink and washes. Some woods are more porous than others and therefore more absorbent. It is a good idea to test each surface to see how the ink behaves when it is applied with a brush, and how it reacts to washes. Ink takes a long time to dry on certain wood surfaces. Natural boards, chipboard, or medium-density fiber board (MDF) can be used.

Wood is a good surface for projects involving dip pens or fountain pens, or for washes done with a brush or any other tool.

INKS

A full range of colors can be created from the small number of available inks. This medium is transparent and luminous, without forgetting the obvious exceptions of India ink, which can be very thick, and white ink, which is dense and opaque.

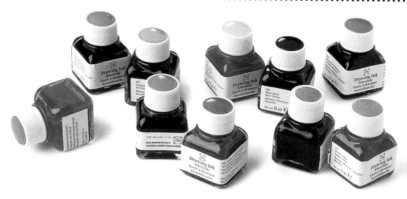

The artist can create a full color palette using the small selection of colored inks.

India Ink

India ink, the most commonly used drawing ink, is black. Its tone is very intense, although it can vary depending on the brand.

This type of ink can also be used for writing because it contains gum arabic. However, the fact that India ink also contains an alkali in its composition makes it suitable for washes, and it can be used to create a wide range of tones.

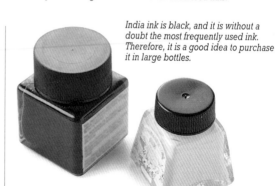

India ink is black, and it is without a doubt the most frequently used ink. Therefore, it is a good idea to purchase it in large bottles.

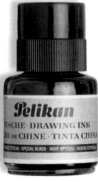

There are many shapes and sizes of ink bottles available, as well as sticks like this Chinese ink.

White Ink

The first inks to appear were India ink and white ink. The latter, unlike all the others, is opaque and denser, which makes it more difficult to use with dip pens or fountain pens. It works best with black or very dark papers. The bottle should be shaken vigorously before using the ink, because the pigment settles on the bottom.

Black ink has a powerful covering capability when it is used straight out of the bottle. White ink is dense and opaque and therefore also covers very well.

A Small Range of Colors

The range of ink colors is not very large, but the medium lends itself to mixing, and this feature is what allows the artist to create an entire color palette.

Some brands offer as many as twenty-five different colors of ink—very few compared with oil paints, for example, which can come in seventy colors or more. However, a reduced palette, with two yellows (one lemon and one canary), one orange, a red, carmine, violet, two or three different blues, two greens, sienna, and sepia, is enough to paint any subject matter and to create the remaining colors by mixing.

Transparency and Luminosity

One of the most outstanding characteristics of colored inks is their transparency. Whether it is a colored ink or a wash, it becomes very transparent once dry, especially on white paper. The whiter the paper, the more obvious its transparency.

Precisely because of this transparency, colored inks are very luminous and have the glossy finish of the gum arabic. Washes, however, reduce the glossiness.

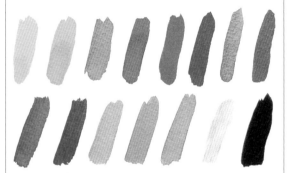

The transparency of the range of colored inks shows the luminosity of the media on white paper.

Inks for Other Uses

There are special inks available with an aniline base for airbrushing. The colors are very bright, although their resistance to light is more limited. The ink in markers has an alcohol base and must be worked using different and specific techniques. Special inks for painting and drawing on canvas are also available. Their colors are opaque and dense, very covering and usually acrylic.

The colors of aniline inks are luminous and bright, but they are also more sensitive to light than the rest.

SUPPORTS, MATERIALS, AND TOOLS

COMPLEMENTARY MATERIAL

The complementary materials for drying the ink are very important, and so is anything that serves to protect the paper.
Blotter paper is essential for drawing, and the absorbent paper towels that are normally used in the kitchen can be used for taking care of spills.

• •

 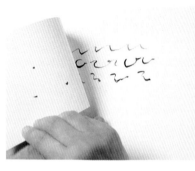

Blotter paper is used to dry every part of the drawing that is wet at the same time.

Prevention

Because inks are indelible, it is important to know how to protect the paper from accidental spills.

One common practice is covering an entire area of the paper as a precaution before beginning to draw.

A clean frame is usually created around the drawing.

Masking tape or paper is quite useful for this purpose. The tape or the paper is removed only when the project is finished and the ink has dried completely.

The corner of a piece of blotter paper can be used to absorb excess ink.

A piece of paper can be used to protect the area of the drawing that is not being worked on from accidental spills.

During the Drawing Session

As the work progresses, another piece of paper, smaller in size than the one we are drawing on, can be used to protect the area not being worked and to prevent the hand from touching the work that has already been done. For this purpose, drawing paper or even blotter

Certain commonly used objects, such as a piece of twine, a cut-off eraser, or a chain, can be useful tools for drawing with white ink.

paper can be used. Care must be taken to make sure that the paper is not placed over part of a drawing until it is completely dry.

Auxiliary Papers

When unwanted marks occur, they can be corrected before the ink dries if we react quickly. Blotter paper, a piece of absorbent paper towel, or similar materials are essential for cleaning a spill or unwanted lines. These papers absorb the wet accident and reduce, as much as possible, the intensity of the ink.

Different Drying Times

It is very common for artistic drawings created with ink to have a variety of pen-stroke or brush-stroke intensities that require different amounts of ink. Therefore, not every part of the drawing will dry at the same rate. It is best to let the work dry naturally, but sometimes, under certain circumstances, it may be necessary to lay blotter paper over the drawing to make sure the ink is thoroughly and completely dry so no accidental smearing occurs.

MORE ON THIS SUBJECT

• More Complementary Material
 p. 38

Experimenting with Different Absorbencies

Any material that will absorb ink can be considered an art tool that, properly handled, can create different textures while the ink is still wet.

Cotton swabs, or even a piece of cotton fabric with a prominent weave, can be used to create interesting effects on ink that has been recently applied.

A piece of twine, cord, or ribbon can also produce special designs. In fact, there are countless objects that are suitable for creating textures. It is simply a matter of imagination and creativity.

Many objects can be used to create textures when they are applied on wet ink:
1. a piece of blotter paper absorbs the ink, creating areas of lighter color;
2. a dry, clean brush can be used to remove ink from a series of parallel lines;
3. a brush or a dip pen creates water effects.

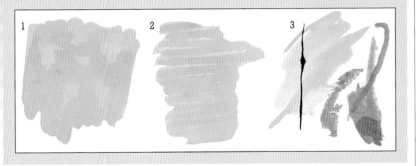

MORE COMPLEMENTARY MATERIAL

When using mixtures of colors, it is necessary to have a palette and wells.
One receptacle per mixture is needed. Masking liquid, certain auxiliary products, and several specific tools are necessary, or very useful, during particular stages of the ink process.

The Palette and the Wells

Whenever several different colors are used, or when it is necessary to work separately with different tones of the same color, a palette or several small containers are recommended. The tool most commonly used is the special watercolor palette, which consists of several compartments or spaces that are essential for keeping the mixtures separate from each other.

The palette and the wells are indispensable for working with several paints or inks.

Masking Liquid

Masking liquid is used to reserve certain areas of the paper that are not to be covered with ink. When the masking liquid is dry, it completely repels the ink. Then, when the drawing is dry, the masking is easily removed, leaving the paper underneath perfectly clean. This type of masking is suitable when the work involves brushes, and more difficult to use with dip or reed pens.

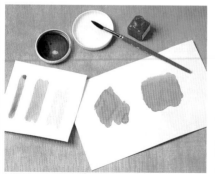

Gum arabic added to ink retards the drying process and gives the work a shinier finish.

White Wax

White wax is also used as a resist. This method is not as efficient as the masking liquid, but it is very useful for edges that do not have to be well defined.

When the layer of ink is dry, the white wax can be applied over it to create a resist for the next ink application.

The Roller and the Sponge

When creating a large ink wash, a considerable amount of diluted ink should be prepared in a large well or plate. Then, to apply it on the paper, it is more practical to use a roller or a sponge than a brush. The roller is used to cover large surfaces evenly.

Masking liquid can be applied with a cotton swab.

Portable Materials

In the studio, materials are at hand whenever they are needed. However, when the artist goes outside to draw from nature, the number of tools has to be reduced. They must be chosen very carefully so as not to take up too much space. Selection always depends on the style of drawing to be made. The tools and the ink are carried in a box or case, inside a bag. India ink, a few colored inks—the most common ones—as well as the drawing pad, the drawing tools (dip pen, reed pen, brush), water (if doing washes), a cotton rag, and absorbent paper are the most common materials.

The portable materials are selected according to the working style of the artist.

Auxiliary Products

Gum arabic delays the drying process of the ink and provides a glossier finish, if such a thing is possible. It is sufficient to add a few drops to the diluted ink.

Ox gall added to the ink or impregnated in the paper will help the wash spread more evenly. Ink spreads farther and flows better, which helps when the paper used is too porous.

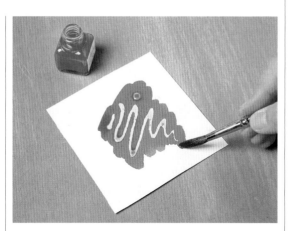

When ink is applied, the masking liquid repels it.

Any tool that is good for scraping can be used to remove the masking liquid after the ink has dried.

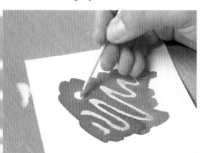

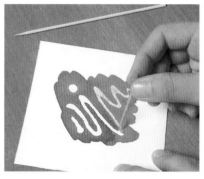

The masking liquid is easily removed.

FRAMING

An ink drawing that has been properly framed can last indefinitely.
Covering it with glass is essential for protecting the paper.
The use of a mat, its color, and the shape and color of the frame give the drawing a finished look. The most common frames are made of wood or aluminum.

Mat board comes in many colors, from which the artist can select the one most appropriate for framing the drawing in harmony with the colors of the paper and the ink.

Temporary Conservation

An ink drawing should be temporarily stored in a portfolio, each work properly protected with a sheet of textured or tissue paper. The portfolio, which can be useful for carrying several drawings at the same time, should not be considered a permanent storage arrangement. With the passage of time, and in the process of adding new drawings

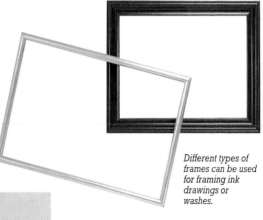

Different types of frames can be used for framing ink drawings or washes.

The color of the paper that has been used as the support is an important factor when deciding the color of the frame and mat.

or removing some for inspection, the paper can get wrinkled, creased, or dirtied.

Permanent Conservation

Ink drawings and washes are conserved in a more permanent way with appropriate framing. The protection consists of a glass sheet in the front, a sheet of wood in the back, and a frame all around (which can be wood, aluminum, or plastic), holding all the parts together. Many ink drawings do not even require a mat, although it can always be included to achieve a more contrasting and decorative effect.

Ink drawings look better with a mat and a frame.

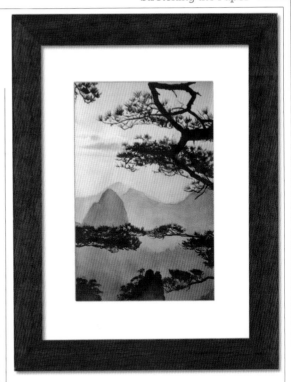

There Are Many Types of Frames

Frames made of wood can have decorative molding, whereas aluminum ones tend to be more lineal and functional. There are many ways of framing an ink drawing or wash. The idea is to achieve a decorative effect by playing with the color of the frame, the color of the mat, and the color of the drawing itself. The shape of the frame, in addition to its color, is another decorative element that must be taken into account.

The Colors of Mat

Specialty stores carry mats in a large variety of colors. It is the first material that frames the drawing and that is in direct contact with it. The color of the mat is very important because it should be chosen to complement, or contrast with, the color of the drawing's paper and the color of the ink or inks. The mat is a sheet of cardboard 1/16 inch (2 mm) or more thick, over which colored paper or fabric is glued.

Aluminum Frames

This type of frame is very practical because it is light and strong. It consists of a series of pieces specifically designed to hold the four aluminum components together. It is without a doubt an ideal frame, especially for small-format drawings in a functional style.

The aluminum frame includes the necessary metal pieces to hold all the parts together.

STRETCHING THE PAPER

A paper or cardboard that is not very heavy must be well attached to a board to give it rigidity.
The board itself should be placed on the artist's lap and held in place with the free hand so it does not move during the drawing process.

• •

Preparation

Before work begins, the paper should be placed on a smooth board, somewhat larger than the paper itself. It can be attached with clips if the project is an ink drawing. However, for a wash, the paper must be stretched on the board to prevent buckling.

When working with wide

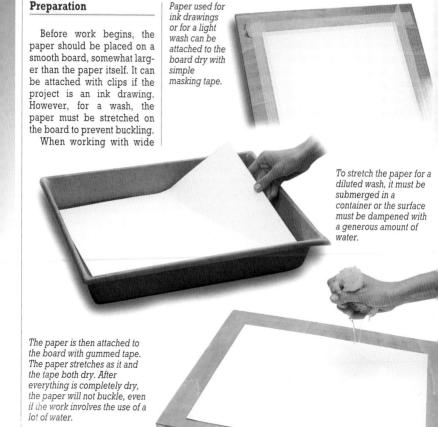

Paper used for ink drawings or for a light wash can be attached to the board dry with simple masking tape.

To stretch the paper for a diluted wash, it must be submerged in a container or the surface must be dampened with a generous amount of water.

The paper is then attached to the board with gummed tape. The paper stretches as it and the tape both dry. After everything is completely dry, the paper will not buckle, even if the work involves the use of a lot of water.

When the artist draws with ink or washes in a seated position, without a table or easel, the portfolio can double as a drawing board. It should be rested on the lap, properly tilted, and held with the hand that is not used for drawing.

The Easel for Ink

To draw with a dip pen, reed, or fountain pen, the tool must be held in the correct position for the ink to flow. It is very difficult to use ink if the angle of the paper is too vertical. Not all easels are suitable for drawing outdoors. The most functional ones are collapsible and allow the drawing board to sit in a nearly horizontal position.

MORE ON THIS SUBJECT

- Precautions While Working **p. 44**
- The Water **p. 46**
- The Work Place **p. 48**

paper tape, it is very common to use the same tape that attaches the paper to the support to set the boundaries for the work.

The Drawing Table

In the studio, the artist normally works with a pen or brush while resting the board with the paper on a drawing table. Although a surface that is flat and hard, like a table, does not require it, an additional board, is a good idea for several reasons. For example, if the table cannot be tilted, a book can be placed under the top part of the board to make the process of applying the wash easier. Also, the board can always be moved to change the position of the paper without touching the drawing.

The metal easel is ideal for drawing with ink and for washes, because the board with the attached paper can be held in a nearly horizontal position.

Without a Table or an Easel

When the artist goes to draw outdoors and does not want to carry too many things, using a table or an easel is out of the question. A surface can be improvised to serve as a table, or simply for holding the board properly secured while drawing. It is also important to place the ink source strategically to prevent ink from accidentally spilling on the paper while being carried from the inkwell to the drawing.

PRECAUTIONS WHILE WORKING

Caution and prevention are without a doubt the two important keys to drawing or painting with ink. Accidental spills and unwanted blotches must be avoided at all costs. The rules for working safely are a matter of common sense and can be applied to every technique.

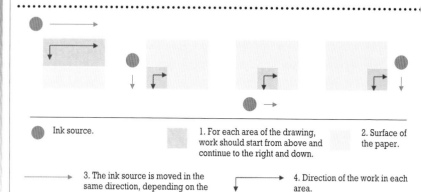

Ink source.

1. For each area of the drawing, work should start from above and continue to the right and down.

2. Surface of the paper.

3. The ink source is moved in the same direction, depending on the area being worked on.

4. Direction of the work in each area.

The inkwell should be located in a convenient place. In this case, the locations from which ink can be used comfortably are suitable for a right-handed person. For a left-handed person, the directions would be from right to left.

The Parameters

There are several things to keep in mind to prevent accidental spills and blotches. One consists of placing the ink source in an appropriate location during the drawing process. The choice of location will depend on the movement of the pen from that point to the area that is being worked on. In addition, the board holding the paper can be posi-

The pencil sketch is used to lay out and block in the shapes of the drawing.

The Order of Work

The starting point is the sketch, which can be created with fine pencil lines that will be erased once the drawing is finished and the ink is completely dry.

The normal work order is always to begin with the background, which is given less contrast and definition than closer objects. Experienced artists usually start on the top left side and continue toward the right. Also, they work in strips and by element, advancing from the top of the drawing to the bottom. A left-handed person would proceed in the opposite direction, progressing from right to left.

Double or triple hatching, and washes that are drawn or applied over the dry ink to enhance the tones, must be executed with the same care.

The background is worked on first when using inks.

taken so the ink does not drip, such as placing the open palm of the other hand under the tool.

Positioning the Paper

The position of the paper is often changed to make work easier. The position of the wrist should be comfortable so it can exert the same control from the beginning to the end of each line. This way the area the pen travels across can also be adjusted.

This is common practice once the main areas that have to be worked on are well defined, and when they require drawing double or triple hatch lines.

ioned as needed for the most comfort when drawing, projecting the rest of the work at the same time.

Situating the Ink Container

The ink container can be an ink bottle that is used when the work is done with a dip pen or reed pen, or with a brush and undiluted ink. For diluted ink, a well and a palette are the tools of choice. These containers must be placed relatively close to the work area on either side, but not so close as to damage the drawing if the container tips over.

The Pen's Travel

From the ink source to the area being worked on, the pen will travel over some part of the drawing. The pen or brush

should not be overloaded, to avoid dripping on the work. Additional measures can be

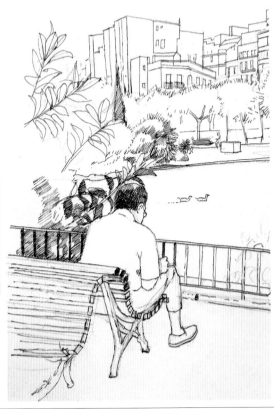

Inking begins, and all the important elements of the drawing are defined. Then, the rest of the lines are laid out over this base until all the required contrast is created.

THE WATER

Water is essential, not only for any wash and wet-on-wet technique, but also for reducing color intensity and washing the tools. Although distilled water is recommended for painting, many artists use tap water.

● ●

With Wet Paper

Working with ink on paper that has been previously dampened with water produces very interesting and special results. A dip pen, reed pen, or brush used on part of the paper dampened with water produces a line with ragged edges.

Water for Washes

Distilled water is recommended for diluting ink. The general procedure for washes

Ink is removed from the bottle by using the dropper that comes with it.

consists of transferring a little bit of ink from the bottle to a dish or well. A large dish with a lot of water can supply enough ink for a large wash. The diluted ink contained in a well is sufficient for a small wash.

Washes on Wet Paper

Special effects can be created when both wet techniques—dampening the paper with clean water, and the wash—are combined. These are very subtle graded washes, which contrast with the harshness of undiluted ink or with the definition of a wash on dry paper.

This technique applied directly is very useful for creating the background. For exam-

ple, a cloudy effect can be created immediately with a wash on wet paper, using small touches of the brush.

Distilled water is used to prepare washes with a little bit of ink that is poured into a well.

If the bottle does not come with a dropper, it is a good idea to get one to prevent the ink in the bottle from getting dirty. It is also very useful for extracting the required amount of ink without difficulty.

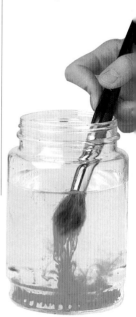

Washing a brush requires a generous amount of clean water, so the water in the jar used for cleaning will have to be changed often.

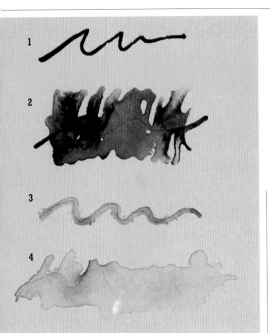

1. *Undiluted ink on dry paper with dip pen and brush.*
2. *Undiluted ink on wet paper with dip pen and brush.*
3. *Diluted ink for a wash on dry paper with dip pen and brush.*
4. *Diluted ink for a wash on wet paper with a dip pen and brush.*

Suspended Particles

When too much water is added to certain inks to make a wash, particles of color can be seen suspended in the ink. However, there are other inks that, properly prepared for a wash, make a solution with an even consistency. In any case, the possible spotted effect remains visible on the paper when the wash dries, and it can be used to enrich the texture.

Thinning with Water

An area of color that is still wet can be thinned by adding clean water.

The tone that is left after excess water is removed with a corner of blotter paper or with a clean brush is lighter than the original.

On the other hand, a brush stroke or area of color that is completely dry cannot be thinned with water unless water-soluble colors that are not indelible are used.

On wet paper:
1. *Color applied on a very wet surface reduces the tone and creates beautiful streaks.*
2. *The effect created by applying a few touches of the brush here and there with diluted ink wash resembles a cloudy sky.*

TECHNIQUES AND PRACTICE

THE WORK PLACE

The conditions of the studio should support the work that will take place in it with comfort and safety. Two aspects could be basically summarized: appropriate and sufficient light is required, and the space should be ample, stable, and well organized.

Light

Direct sunlight on the paper should be avoided because it is very harmful to the eyes. The artist should establish the most appropriate working position for optimum lighting. The hand used for drawing should not cast any shadows on the area that is being worked on.

When drawing from a model, the artist should position himself so that there is a proper background, with enough light and with no blinding reflections on the paper.

When there is artificial light in the studio, it is important to direct it so that it does not create disturbing reflections on the paper. In the same way, no type of lighting should cast any shadows that would block the visibility of the drawing area.

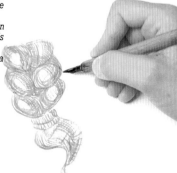

Light should illuminate the drawing without casting any shadows in the area where work is being carried out, whether a dip pen or a brush is being used.

In the Studio

Thanks to the amenities afforded by the studio, it is easier to be careful with the ink container. The main danger of working with a dip pen or reed pen, or a brush that the artist must dip directly into the bottle, is the possibility of the container tipping over. This can happen when the tool is being inserted or taken out of the bottle without paying attention. With washes, accidental dripping can happen when the brush is charged with too much ink.

In the studio, many problems can be prevented simply by placing the ink bottle, the palette, or the well on the table or top of a stack of blotter paper. Paper towels can also be handy for this purpose. This way, any excess ink or wash can be absorbed immediately. Therefore, in addition to finding the most convenient place for the ink source, the artist must pre-

To prevent the brush from dripping, excess liquid can be removed by pressing it against the edge of the inkwell.

Practice

With practice, wash or pen techniques can be carried out even under conditions that are not the least bit favorable to the manipulation of tools and drawing materials.

M. Braunstein created this India ink wash from a life model with a brush, and finished it with outlines made with a dip pen.

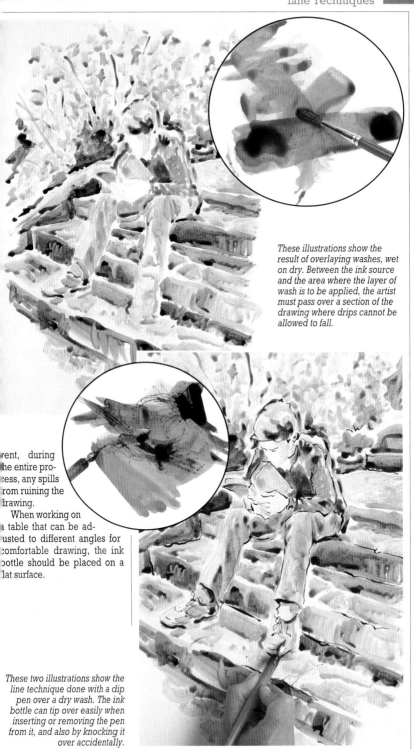

These illustrations show the result of overlaying washes, wet on dry. Between the ink source and the area where the layer of wash is to be applied, the artist must pass over a section of the drawing where drips cannot be allowed to fall.

vent, during the entire process, any spills from ruining the drawing.

When working on a table that can be adjusted to different angles for comfortable drawing, the ink bottle should be placed on a flat surface.

These two illustrations show the line technique done with a dip pen over a dry wash. The ink bottle can tip over easily when inserting or removing the pen from it, and also by knocking it over accidentally.

LINE TECHNIQUES

Basically, line techniques are employed for making a drawing. The isolated line can define an outline, and a series of lines is used for modeling. Classic tools like the dip pen and reed pen are used for line drawings with ink.

The Line

The line is the basis for any sketch, and it can be straight, round, or mixed. The single line is generally used for drawing the silhouette of the model, although there are drawing techniques that can represent light that do not require outlines.

The Width

Constant-width lines are those that maintain the same thickness throughout their length. Lines are said to have a variable width when some of their sections have different thicknesses. A flexible dip pen can be used to create both

The dip pen is the perfect tool for quick sketches. The silhouette is described with a single line and the shadows with a series of parallel ones.

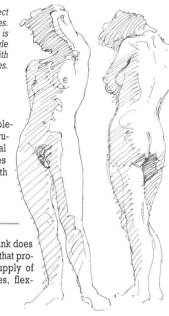

constant and variable-width lines. Other instruments, such as technical pens, can make lines with a constant width only.

The Intensity

The intensity of the ink does not change with a pen that provides a continuous supply of ink. However, brushes, flex-

The Length of the Line

A line should be short enough to be drawn with a single charge of ink, whether it comes from a dip pen, quill, reed pen, or brush. Its length will vary, depending on the tool and the type of paper used (the more absorbent the paper the shorter the line). However, in the case of technical pens, which provide a continuous flow of ink, the length of the line will depend on the steady hand of the artist.

ible dip pens, and reed or quill pens make lines of various intensities. The challenge of these tools is precisely the fact that it is difficult to maintain the same intensity throughout.

The Artistic Line

In an artistic line, both the intensity of the ink and the width of the line may vary.

An artistic line is without a doubt the best way to describe a form. The variations of line and intensity suggest a feeling of depth and help describe the volume.

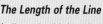

The brush is also used for the line technique.

The artistic sketch is executed with a steady hand and describes the characteristics of the subject matter to perfection.

The spontaneity of a drawing created with artistic lines is evident. Drawing by Vicenç Ballestar.

Sketching

The paper is tested, using the tool we have chosen to get a feel for how it reacts. These tests are necessary every time a new material is used, whether it is the paper or the drawing tool, and even the ink. Then, the best way to practice line-drawing techniques is by doing quick sketches. To draw from life, it is best to begin with a still life and later, after gaining experience, to continue with the human figure. Sketching consists of drawing a simple contour with the most artistic line possible. These first sketches may include just a vague representation of the areas of light and shadow, expressed by simple lines that constitute the first practical application of the line technique.

This drawing, created by M. Braunstein in sienna, combines washes applied with the brush and lines created with a dip pen.

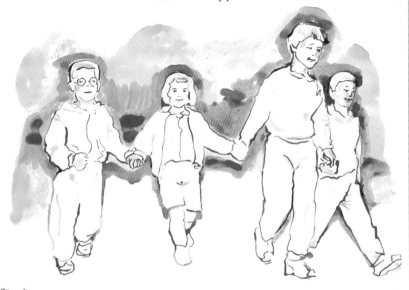

LINE TECHNIQUES AND DRAWING INSTRUMENTS

The drawing instrument is a key element in the execution of the line sketch, whether it is positive or negative drawing. The comparison between the two results is useful for understanding the characteristics of each one of them in relation to the drawing.

The Quill Pen Line

The direction in which the tip is drawn across the paper determines the width of the line, from very heavy to very fine. The flexibility is such that artistic lines can be made with variations of thickness and intensity. The artist must keep in mind that the supply of ink, which is held in the quill's tip, does not flow as smoothly as the ink in a dip pen.

The Dip Pen Line

Flexible dip pens can even be used for drawing with the back of the nib. The direction of the line with respect to the position of the nib makes it

A negative drawing is created on scratchboard. First, the entire surface is covered with India ink and then the white areas are created by removing the black ink with a sharp-pointed tool.

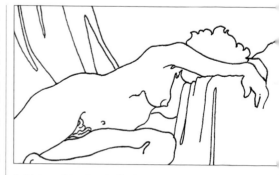

In this type of drawing, the line has to be precise, whether it is curved or straight.

Straight, curved, and mixed lines drawn with a dip pen (1), reed pen (2), and a quill (3).

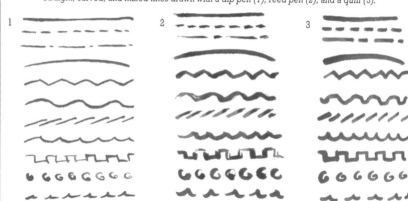

Drawing Lines with a Brush

Brush strokes can be thin or wide, depending on how much pressure is applied to the brush. Fine brush strokes can also have more or less intensity, according to the pressure exerted on the paper and the amount of ink the brush holds.

The amount of ink in the brush can be controlled. But always remember that less ink means less capability for making lines of equal intensity.

The characteristic hallmark of the artwork created with a brush is precisely the result of the variations in intensity within the same brush stroke. Besides, only thin and hard brush strokes can compete with the consistency of the lines made with a dip or reed pen.

The Technical Pen Line

The tubular-tip pen is an instrument that draws continuous lines of constant width. This pen was basically created for technical drawing. However, in the hands of an artist, with several tips of various thicknesses, it can produce very artistic results.

Work can also be done on paper colored black with India ink and left to dry, using a dip pen and white ink.

possible to create two fine lines of different widths. The nib's flexibility means that when pressure is applied (always slanted, forming a small angle in the direction of the line), the line can become increasingly wide. However, the wider it is, the greater the amount of ink used, so the length of the line will decrease.

The Reed Pen Line

The way the reed pen makes contact with the paper is special. It rubs rather than glides across it, and the lines created are very distinctive. Their characteristics are unmistakable.

The Fountain Pen Line

The nibs of fountain pens tend to be quite rigid. This is why drawings created with a fountain pen maintain a constant thickness throughout the drawing. However, varying the pressure on the paper can produce two or three intensities, one soft, one normal, and another stronger. In addition, the ends of the lines are somewhat rounded, another unique quality.

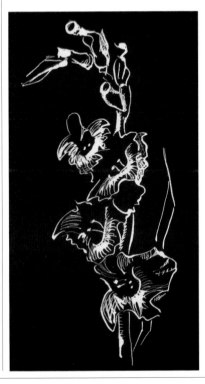

A drawing made with pen and white ink can also be done on black cardboard.

SHADING WITH LINES, TONES

Lines are the basis of all the shading that is created with hatching. Various tones can be made with India ink and colored ink, which, correctly applied on the paper, can be used to model a form.

• •

Hatching

A dot is the smallest element that can be used to create different color tones or shading. For a light tone, the dot density on a surface must be low. As their density increases, the tones become progressively darker.

Simple hatching can be created by drawing a series of parallel or curved lines in repeated succession one over the other. The lightest tone is created with a series of well-spaced parallel lines. The darkest ones are made by increasing the density of lines or by applying several series of parallel lines, one over the other, in various directions. The

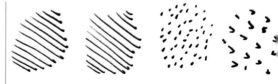

Different elements that form the drawing: straight and parallel lines, dots, and V-shapes can be used for hatching, shading, and coloring.

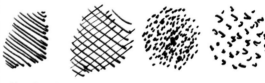

To make a light tone, the density of the hatching must be low. On the other hand, to create a dark tone the density of the hatching must be higher: parallel lines, crosshatching, dots, and V-shapes.

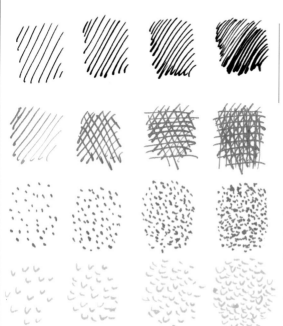

denser the hatching, the darker the tone will be.

Any element, even squiggles, can be used to draw some kind of hatching, which can be used to produce a special effect.

A tonal range, from lighter to darker, can be created with the same type of elements, by increasing or decreasing the intensity of the lines. The different tonal ranges can be used together or separately in the same drawing. When two or more hatchings are used together, a relationship must be created between the different tonal values.

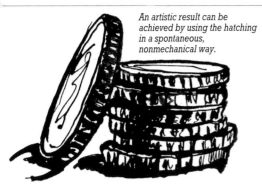

An artistic result can be achieved by using the hatching in a spontaneous, nonmechanical way.

Covering an Area

Because the basis of hatching is the line, its length determines the space that can be covered each time. The hatching process starts in a particular area, and then one section is successively connected with the next until the entire space, previously marked on the paper, is covered with the specific tone. With practice, the areas that have a similar significance are covered at the same time. This way, gaps and seams, which always diminish the value of the drawing and its ability to represent the model, are avoided.

Tones

The different tones created by hatching can be classified into a tonal range. From the lightest tone to the darkest, there are as many types of hatching as purposes for which they are intended.

Every range that has been created with a different process does not necessarily have to be used separately. Some drawings incorporate one type of hatching for the background, another for the middle ground, and a third for the foreground. If we observe the different tones of all the possible ranges, a gradation can be created by inserting their values among them. The examples from the previous page show a wide range.

Shading with hatching requires practice covering an area with perfectly parallel lines.

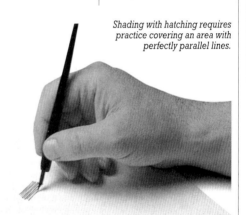

The Direction of the Hatching

The direction of the parallel marks in a simple line hatching, or the general direction of the series of superimposed lines, should express the visual perspective of the model as well as possible. These directions must take into account the perspective in every case, be it of a single vanishing point or parallel lines, two vanishing points or oblique lines, or three vanishing points or aerial perspective.

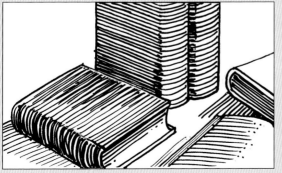

With a series of parallel lines, which is the simplest hatching to do, a drawing begins to acquire depth. The direction of each series of parallel lines explains the depth of the model by projecting each group of lines toward the corresponding vanishing point.

DILUTED INK, TONES

With washes, coloring or shading by tones can be done very easily.
A brush is the most appropriate tool for the task, but it is also possible to use a dip pen or reed pen by making the ink run, as if it were a stain, with the tip of the pen.

Tones with Diluted Ink

With undiluted ink, tones can be created only by spacing or condensing the hatch lines. However, shading or coloring is possible with the wash process, because water is added to dilute the ink.

When a lot of water is used with a little ink, the resulting tone is very light. As the proportion of ink increases in relation to the water, the tone becomes darker.

Although a brush is the traditional tool for washes, different tones can be created by applying the ink with a dip pen or a reed pen and using hatching.

The Tonal Range with Ink Wash

It is easy to produce the entire range of tones, from the darkest to the lightest. The art-

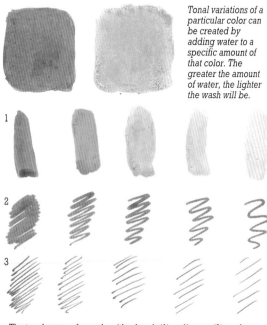

Tonal variations of a particular color can be created by adding water to a specific amount of that color. The greater the amount of water, the lighter the wash will be.

The tonal range of a wash, with a brush (1), a dip pen (2), and a reed pen (3), is created using different tones of ink arranged progressively.

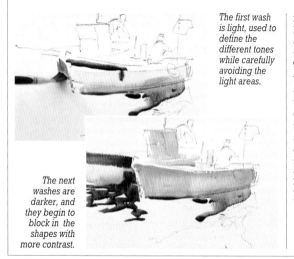

The first wash is light, used to define the different tones while carefully avoiding the light areas.

The next washes are darker, and they begin to block in the shapes with more contrast.

ist must simply charge the brush with India ink or colored ink to create the most intense tone, the darkest of all. The same brush is charged with a little bit of water and reapplied on the paper, next to the first sample. The tone created is lighter. Repeating this until the brush hardly has any ink left, the lightest tone can be created. If instead of the brush, a dip pen or a reed pen is used for hatching, the process will still be the same as described.

The Wet Paper Technique

A common technique among artists who use washes consists of dampening the paper before drawing with a dip pen or brush. It can be dampened from very little to a lot, and each case will produce a different effect. On the other hand, the behavior of the ink on wet paper also depends on the characteristics of the paper itself.

Unlike the lines created with a brush, those drawn with a dip pen or with a reed pen persist. The harder the tip is pressed on the paper, the stronger the mark.

Compare the results of various lines created with a dip pen or reed pen or with a brush on a paper that is dry (1), semiwet (2), and very wet (3).

The mark resulting from the effect of the water depends on the characteristics of each type of paper. The samples on three different types of paper show the results of a dip pen and reed pen on dry paper (1, 2, 3), and on wet paper (1', 2', 3').

Overlaying Tones

Ink washes can be layered once the first application is completely dry. This technique is called wet on dry. The effect of overlaying the washes, which are done with indelible ink, is clean and intensifies the color.

Tones with Washes

With practice, the artist becomes more proficient at doing washes and overlaying them. The first applications consist of a monochromatic wash or a very light gradation.

Brush strokes of practically undiluted ink are normally used to reinforce the contrast in the foreground.

The artist proceeds by taking the overall work into account and adding details here and there with overlaid ink washes, not to make the drawing too harsh.

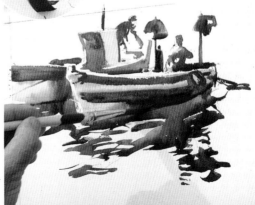

FLAT SHADING

One of the most common techniques used in children's drawings and in comics is done with India ink by using the white of the paper as the lightest color, and the maximum intensity of the black as the only dark value.

Simple Contrast

The simplest value system is based on flat shading or color applications. It is said that shading is flat when it maintains the same tonality throughout the entire application. Normally, shading is done with a brush, but a dip pen can also be used. The ink is spread with the tip of the pen, and more ink is added until the specific area is covered.

Two Values

When the artist works with flat shading, everything is reduced to two single values: the white of the paper and the intense tone of the ink. The silhouette technique devotes the black color to the profiles, which stand out against the white paper, creating great contrast. This technique is common in children's book illustrations.

Another technique consists of reserving the white of the paper for the representation of light, and the darkness of the India ink for the shadows. The personal style of each artist works out the second method with his or her own sense of synthesis, which is what gives personality to comic strips.

Arthur Rackham represents a scene full of vitality with the silhouette style. The graphic power is undeniable, and even more amazing considering the simplicity of the medium used.

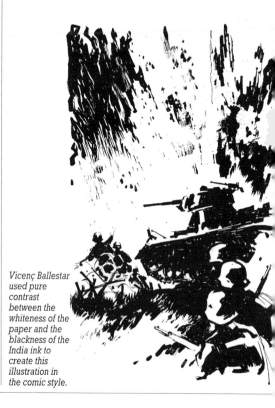

Vicenç Ballestar used pure contrast between the whiteness of the paper and the blackness of the India ink to create this illustration in the comic style.

MORE ON THIS SUBJECT

- Shading with Lines, Tones **p. 54**
- Diluted Ink, Tones **p. 56**
- Color Theory for Ink **p. 62**
- Mixing Inks **p. 64**

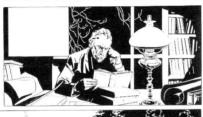

Josep Torres has created a page composed of two vignettes. The narrative link requires a single style, which in this case is based on the perfect balance between the only two values: black and white.

represent the figure is generally moderate, with a few very light washes to prevent darkening the work too much. What is important to emphasize is the line drawing, which highlights the features of the model.

Resources

Even in caricatures, which are based on contour lines and a minimal use of shadow and colors, the artist will use the effect created by surrounding the figure with a dark, flat wash to achieve the maximum contrast. The shading used to

Caricatures, like this one by Manel Puyal, are illustrations where drama and exaggeration have been added to the features. A flat wash of ink serves as the background, against which the main and central figure will stand out.

Flat Washes

Practice is needed to be able to make a wash that is a single tone. It is a good idea to do some tests on a separate piece of paper until you are confident that the same tone can be repeated whenever necessary. But there is no doubt that the challenge lies in achieving a moderate wash, especially if it is large, that looks the same all the way through. The difficulty stems from extending a specific block of colored ink without varying the proportions of water and ink. Work must be carried out very quickly so the wash does not dry and become streaky, which ruins the results. The larger the area to shade or color, the greater the amount of wash must be prepared.

While the wash is still wet, a little bit of water or color can be added to modify the tone, mixing in with a quick brushing motion of the entire area.

When washes are applied with a brush, it is necessary to practice making brush strokes with the same tone (1) and flat washes (2).

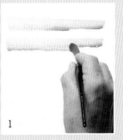

1

2

GRADATION TECHNIQUES

The most commonly used technique for creating volume and depth is grading, where one shade or color gradually merges with the next. It can be done through hatching, with a dip pen, reed, or fountain pen, or as a wash using a brush.

Definition

A gradation consists of creating a shaded or colored area with hatching or with a wash, showing a gradual move from one tone to another, arranged from lightest to darkest or darkest to lightest.

Graded Tones with Undiluted Ink

Several types of hatching can be created without diluting the ink. In pointillism done with a fountain pen, the gradation is achieved by using sparsely placed dots to represent light tones, gradually increasing the density for the darker colors. A well-executed pointillist gradation does not have any tonal gaps or jumps.

When hatching is created with parallel lines, the gradation effect is produced through optical mixing, when the drawing is viewed from a distance. Light colors can be created only by using the dry-brush technique on textured paper, if a brush and undiluted ink are used.

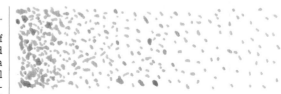

Graded tones can be achieved with pointillism.

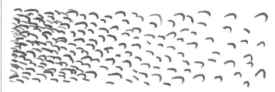

A gradation created with scribbles produces a very interesting effect.

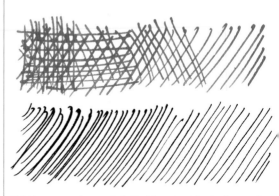

Hatching can create a graded effect through mixing by the eye when the drawing is viewed from an appropriate distance. The finer the pen, the smaller the gaps in the hatching.

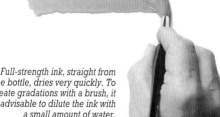

Full-strength ink, straight from the bottle, dries very quickly. To create gradations with a brush, it is advisable to dilute the ink with a small amount of water.

Graded Washes

When a graded wash is applied with a brush, it must be done very quickly. This can be achieved only after practice.

First, the artist must visualize the boundaries of the wash, that is, the area to be covered. Then, the intense color is prepared in a dish. Painting is

Another method consists of laying down a flat wash, and while this is wet, reducing the tone gradually by adding water with the brush and removing color.

A graded wash done with a brush begins with an application of ink and water. The tone should be as intense as required by the overall value of the gradation. Then, the brush is loaded with clean water, and with a wiping motion the color is spread, making it lighter.

MORE ON THIS SUBJECT

- Shading with Lines, Tones **p. 54**
- Diluted Ink, Tones **p. 56**

done with a brush fully loaded with water and ink, beginning with an application as wide as allowed by the size of the brush. The same brush is then loaded with clean water and dipped in the prepared wash. Working quickly over the still-wet ink, the dark tone is washed with the brush into a progressively lighter tone.

First, a flat wash is applied. Then, some color can be removed with a dry brush. Finally, the color is wiped with the brush loaded with water to create graded tones.

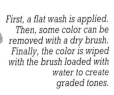

Grading Techniques for Modeling

The lightest part of the graded area is considered the part of the model that receives the most light, and the darkest is related to the one in shadow. Therefore, a gradation is the best possible way to achieve this effect because it gradually goes from the lightest tone to the darkest without gaps. The grading technique is the most suitable for modeling volumes.

This is the look of a dry gradation created with ink.

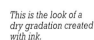

TECHNIQUES AND PRACTICE

COLOR THEORY FOR INK

When several colors of ink are used together in one drawing, they can be layered or mixed directly. It is important to have a basic knowledge of color theory to be able to obtain the desired results when mixing colors.

●●●

Mixing Is Essential

When working with monochromatic inks or washes, shapes can be modeled using tones. But when several colors are introduced, good modeling can be achieved by using specific mixtures of the colors.

Primary Colors

The basic primary ink colors are yellow, carmine, and blue.

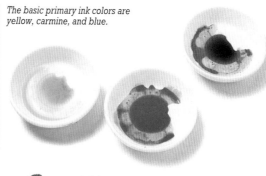

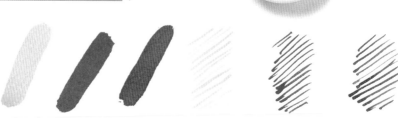

This is a sample of how primary colors look on paper once they dry.

The primary or basic ink colors are the yellow, carmine, and blue that are closest to the yellow, magenta, and cyan (used in the printing industry), chosen from among the small range of ink colors available on the market.

Secondary Colors

When two primary colors are mixed together in equal proportions, a secondary color is obtained. There are three secondary colors: red, from yellow and carmine; green, from yellow and blue; and dark blue, from carmine and blue. A white palette is very useful for checking the quality of the red, dark blue, and green.

Tertiary Colors

A tertiary color is created by mixing three parts of one primary color and one part of another primary. There are six tertiary colors: orange (3 parts yellow and 1 carmine), dark red (3 carmine and 1 yellow), violet (3 carmine and 1 blue), violet blue (3 blue and 1 carmine), yellow green (3 yellow and 1 blue), and blue green (3 blue and 1 yellow).

Intermediate Colors

Mixing all three primary colors in different proportions produces further intermediate colors. For example, there are mixtures of primary colors to create an ochre, a reddish earth-tone color, and a brown color. Yellow ochre is the

result of mixing a large proportion of yellow with a little bit of carmine and very little blue. The reddish earth color is achieved by mixing equal parts of yellow and carmine and adding very little blue. For the brownish tone, carmine and blue are mixed in almost equal parts with a small portion of yellow.

MORE ON THIS SUBJECT

- Mixing Inks **p. 64**
- Direct Mixing **p. 66**
- Contrast Between Colors and Tones **p. 70**
- Harmonious Color Schemes **p. 72**
- The Three Palettes **p. 74**

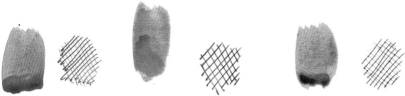

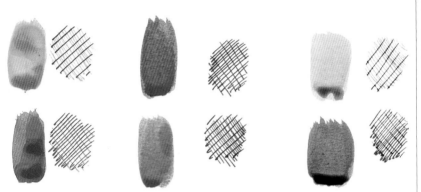

The secondary colors, red, dark blue, and green, can be created by hatching with a dip pen, or by mixing directly with a brush.

The tertiary colors, orange, dark red, violet, violet blue, yellow green, and blue green, can be produced by hatching with a dip pen, or as a mixture applied with a brush.

Intermediate Colors from Complementary Colors

Complementary colors create the most contrast with each other, which can be seen better when they are painted one next to the other.

The purest intermediate colors are the result of combining complementary colors in different proportions. The most important pairs of complementary colors are red and primary blue, secondary blue and yellow, and carmine and secondary green.

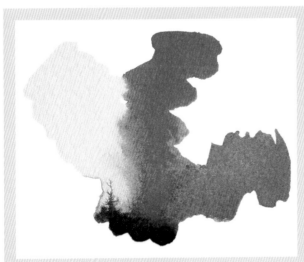

The Color Black

Black is created by mixing the three primary colors (yellow, carmine, and blue) together in equal parts.

This black looks gray when compared with the intense black of India ink.

MIXING INKS

Because there are more colors of ink available than just the primary ones, the main reason to mix them is for tinting commercially produced colors. Working becomes easier and the luminosity of the mixtures is superb, although hatching and washes may look very different.

Clean Color

If a very small amount of carmine is mixed with a base of lemon yellow, the resulting yellow color will have a reddish undertone. But when the artist purchases a commercial canary yellow, the difference is noticeable. It is always better to use a commercially produced color, when available, than a mixed one.

Blending

Even when mixtures are needed, the results will be better if the commercial color closest to the mixture required is used. This manufactured color would only need to be mixed with another commercial color (used in very small proportions) to create the desired shade. At this point, color theory could come in handy for planning the ideal mixture between primary colors that would look closest to the commercial ones. It would also be useful for the effect of the pro-

posed shade and as a result of reducing a specific color into primary colors.

Characteristics of Manufactured Colors

The chromatic characteristics of commercial colors directly affect the result of any shades or mixtures. For example, the orange that is obtained by mixing red or carmine and yellow depends on the characteristics of the red, the carmine, and the yellow, as well as on the proportions used to create it. Depending on the color of the mixture needed, common sense will

MORE ON THIS SUBJECT

- Color Theory for Ink **p. 62**
- Direct Mixing **p. 66**
- Contrast Between Colors and Tones **p. 70**
- Harmonious Color Schemes **p. 72**

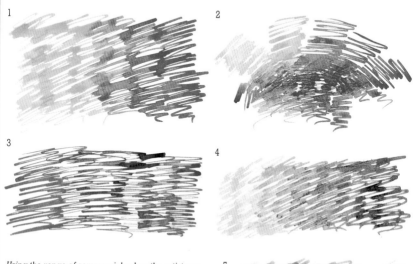

Using the range of commercial colors the artist can create gradations between two colors, through simple hatching done with a dip pen:
1. Yellows, reds, and carmine. 2. Yellows, reds, and carmine, darkened and shaded with sienna and sepia. 3. Carmine, violets, and blues. 4. Yellows, greens, and blue. 5. Another color can be superimposed, like the orange applied to the previous gradation.

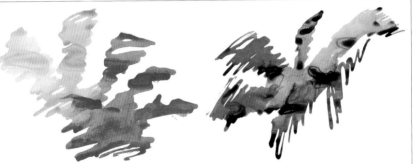

Ink can be mixed directly on the paper using a brush.

Inks can also be mixed on the palette, being careful not to contaminate the contents of the bottles in the process.

dictate whether to use the lemon yellow or canary yellow.

The Selection of Ink Colors

Ink does not come in a wide variety of colors. But those that are available are more than enough to mix any additional color that is required. The ink palette includes two yellows: one very light with a green undertone, and the other with an orange tendency. Then there is the orange, one red, and a carmine or pink. In the violet range is a reddish one and another that is more blue. In the family of blues, the most commonly used is ultramarine blue, although indigo is also available. The greens include apple green, light green, and viridian. The earth tones sepia and sienna are also available, as are, of course, white, and India ink for black.

Any Color Through Mixing

Yellows, reds, violets, blues, greens, and earth colors give the artist the ability to mix any required color. The characteristics of the mixture are better perceived on a white porcelain plate. Ink is a very transparent medium, so the color will stand out against any background that is extremely white and luminous.

Wet ink is more luminous and bright than after it has dried, always varying with the type of paper. If the support is more absorbent, it reduces the glossiness and luminosity of the lacquer. This is why it is recommended to test the mixture on a piece of scrap paper first and then decide if the brightness is acceptable, while also keeping in mind the tone of the color.

Commercial sienna and sepia tones mixed with other colors result in further intermediate colors.

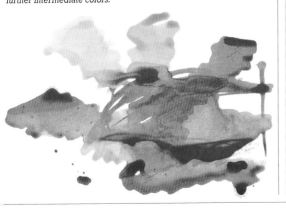

DIRECT MIXING

Colors can be mixed directly on the palette. But ink can also be mixed on the paper while it is still wet, creating variegated colors, or overlaying them wet on dry, producing luminous results as well.

Mixing on the Palette

Two or more ink colors can be mixed directly on the palette. Because ink is a very light medium, the wells must be used to keep each mixed color separate from the rest. Only a small amount of mixed ink is needed for small washes or for working with the dip pen. However, it is always better to have more than you need, because if you run out, it will take some time to prepare another mixture that is exactly like the first one.

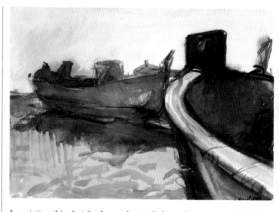

In painting this sketch of some boats, light washes were applied first. The sky is left as is, and the sand and the shapes of the boats were produced by overlaying washes to mix the different inks directly on the paper, over dry or still-wet washes.

Mixing on the Paper

Colors can be mixed directly on the paper. To this end, it is essential for the ink on the paper to still be wet when the second color is added. A variegated blend between the two ink colors will result, without definite boundaries between them. These brush strokes have a painterly quality.

There are several points to keep in mind for this technique to be successful. It can be useful to dampen the paper with water beforehand. Also, gum arabic can be added to the ink to delay the drying process, or a few drops of mineral spirits can be mixed in to add drama to the variegated effect.

Gum Arabic

Gum arabic is a medium that is used as a thinner for tempera, increasing its transparency and elasticity. For the same reason, it is also very useful for watercolors. In the case of inks, gum arabic delays the drying process like it does for tempera and watercolors. This property

A palette like this one allows the artist to have ink mixtures ready when they are needed.

MORE ON THIS SUBJECT

- Mixing Inks **p. 64**
- Contrast Between Colors and Tones **p. 70**
- Harmonious Color Schemes **p. 72**
- The Three Palettes **p. 74**

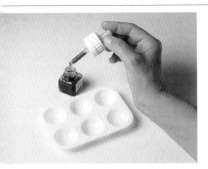

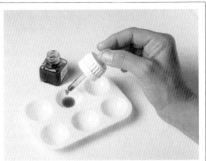

is important for inks, because if they dry too fast, it is difficult to mix wet on wet unless the paper has been previously dampened with a little water.

A practical way to prepare several direct mixtures on the palette is to use a dropper for extracting the ink from the bottle and dropping it in the compartment. The dropper can be cleaned easily, and it must be done every time the color is changed.

Turpentine and Salt

Even though turpentine is a product that is generally identified with oil paints, it has proven itself useful with inks as well. Just a few drops on wet or dry paper create color effects that are impossible to produce with the brush alone, because of their spontaneity and freshness.

Salt is another product that is used to create special textures. The effect on a color is very different from that obtained with a few drops of turpentine. It is interesting to incorporate it into the wet-on-wet technique with the intention of creating variegated mixtures.

Very interesting effects can be obtained by spreading a few grains of salt on the paper before the first wash, or by adding it to the painted area just after the first application.

The wet-on-wet technique can be completed with turpentine, which will create texture effects in the color.

TECHNIQUES AND PRACTICE

CROSSHATCHING

Crosshatching is a technique that can be used to create contrast among different areas of the work. It is also useful for making gradations to model the shapes. It is not uncommon for the artist to have a personal hatching style.

The Different Planes

The planes that can be observed when looking at a subject are defined by their relative distance to the viewer. The most distant plane is the one that becomes the background in the picture. The closest plane corresponds to the area near the viewer. Depending on the model, one or more intermediate planes can be established.

It is all a matter of imagining hypothetical vertical planes cutting through the horizontal plane. Each vertical plane would represent a ground in its proper order, from the nearest to the farthest away.

Contrast in the Representation

To prevent the drawing from looking flat, it is a good idea to work at creating sufficient contrast between the distant plane, the intermediate plane or planes, and the one closest to the viewer. There should be less contrast between the farthest plane and the intermediate one that is closest to it. The contrast between planes should increase as one approaches the foreground, which should have the most contrast.

Tones for Creating Contrast

Two different tones applied next to each other with a small gap between them will ensure a contrast. When working with the same type of hatching to create a tonal range, the tones must be quite different to achieve any contrast.

The difference between planes is established from the beginning. The dark black is used for the arch in the foreground, and the background remains white.

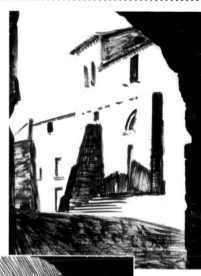

The lightest hatching is used for the background, respecting the play of light and shadow that is so pronounced in this picture.

Contrast Between Hatching

Juxtaposing different types of hatching allows the artist to increase or decrease the effect of contrast. Light dots next to a dense line hatching will always create pronounced contrast. A similar contrast effect can be produced by drawing simple, parallel line hatching with a crosshatching side by side.

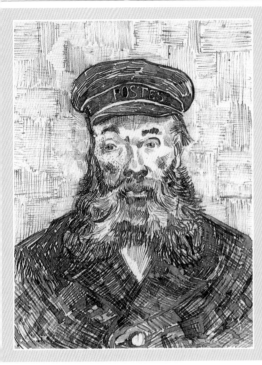

Maximum Contrast

When maximum contrast is required, it can be created by drawing heavy, intense lines over hatching, which results in lighter tones in an optical mixture.

This type of hatching, done with a dip pen, requires a good charge of ink. Pressure on the pen's tip then narrows or widens the lines as needed until the entire area requiring great contrast is completely covered.

Van Gogh used contrast between two types of hatching on a regular basis, producing dramatic effects. Straight and curved lines intertwine and create a remarkable rhythm, as can be seen in this drawing titled Joseph Roulin, Head.

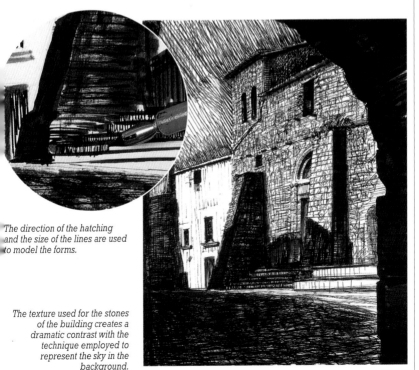

The direction of the hatching and the size of the lines are used to model the forms.

The texture used for the stones of the building creates a dramatic contrast with the technique employed to represent the sky in the background.

CONTRAST BETWEEN COLORS AND TONES

When inks of various colors are used, the fact that they are different already guarantees some contrast. If, in addition, the ink is diluted or hatching is used, the contrast is enhanced through tonal change. Therefore, contrast can be achieved by color and by tone.

Diluted Color and Tones

By diluting a commercial color, lighter tones can be obtained, which will help model the form. Also, depth is represented by simply using tonal values, without the need for hatching. A monochromatic project is no more complicated

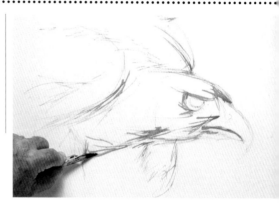

The tip of the reed pen can be used to apply a very light blue tone.

than making the lighter tones match the more illuminated areas, and the darker tones match the areas that represent the progression of the shadows to darkness.

Contrast Between Colors

Contrast between colors alone can be used to represent the model properly, without having to dilute them.

The hatching technique produces different color tones.

Wide lines that look like streaks can be made by drawing with the angled side of a reed pen's tip.

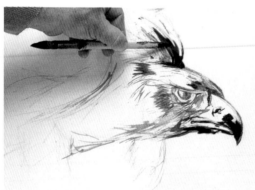

Lines created with a dip pen can be very fine or very heavy, like this one. Switching to this tool offers the possibility of creating small marks, which are hard to draw with a reed pen.

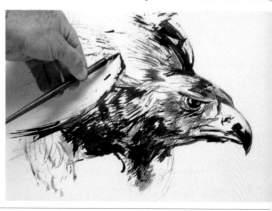

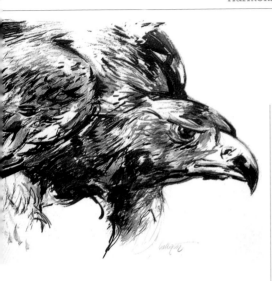

Contrast and modeling are guaranteed through the contrast created between diluted and undiluted ink, the colors, the change of drawing tools, and the type of hatching. Work by Vicenç Ballestar.

Contrast with Drawing Tools

The effects of both colors and tones are modified, depending on the tool used to apply them. Brushes, reed pens, or dip pens differ from one another because of the distinctive marks they produce, in terms of the length of the lines they can create and the amount of ink or wash they can hold. Contrasts can be created using the different values of these lines.

eaving white areas of the paper to represent the different tonal values.

When comparing two colors, one always appears lighter or darker than the other one. Therefore, the darker color can be used to darken

the tone of the lighter color. This procedure is a way to model shapes by creating the necessary contrast between the different planes.

MORE ON THIS SUBJECT

- Shading with Lines, Tones **p. 54**
- Diluted Ink, Tones **p. 56**

The Contrast Between a Brush and a Dip Pen

One very useful form of contrast is playing off the effect of work done with a brush and the lines drawn with a reed pen.

Very soft, medium-tone wash gradations can be created with a brush. The dip pen can be used to draw lines layered over the wash to produce a shading effect. However, the dip pen is most commonly reserved for drawing simple contour lines. It produces a strong contrast that is especially useful for bringing out one plane against the other.

Different tones can be created with a brush and diluted sienna ink. The artistic drawing of the contours provides the contrast that describes the gesture and the volume. Drawing by M. Braunstein.

HARMONIOUS COLOR SCHEMES

The three harmonious color schemes are warm, cool, and neutral. They are a good reference for establishing the general tendency of the drawing's color beforehand. It is not necessary to use the complete scheme in a project.

A Dominant Color

The simplest way to set the tone of a drawing's color is to establish a hue that is close to the dominant color of the model. For example, if the dominant color is orange, the artist needs only to mix all of the commercial colors with this orange. The resulting mixtures will acquire a general orange tone.

A Good Method

A good way to create a harmonious result without establishing a dominant color consists of working with the so-called harmonious color schemes. There are three general harmonious color schemes: warm, cool, and neutral. The latter can also have a warm, cool, or neutral tendency.

Creating a Color Scheme

To work with a generally warm color scheme means that most of the hues and mixtures that are used are warm colors: yellows, oranges, reds, carmine, and earth tones. The cool colors, such as greens and blues, are good for blending and darkening these warm colors or mixtures.

To create an overall cool color scheme, mainly

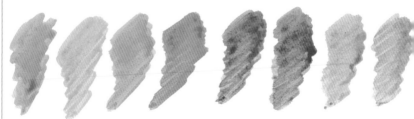

This scheme was created using orange as the dominant color. The artist must simply mix each color of the palette with orange. All the mixtures are somewhat orange.

The warm colors of the palette are mixed to produce a warm color scheme. Warm colors are mixed together, reserving the cool ones for blending and darkening.

A cool palette is created by mixing with cool commercial colors.

A Simple, Harmonious Color Scheme

One dominant color is established, which is then tinted with its complementary color and with the two colors that are next to it on the color wheel. It is a color scheme that must be developed by tinting, that is, by adding just a little bit of a complementary color or one that agrees with the dominant color, so as not to create too strong a contrast.

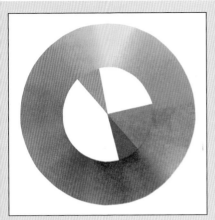

Illustration of a color wheel, which shows a simple, harmonious color scheme.

commercial cool colors are used: blues and greens. The remaining warm commercial colors are used in small quantities to blend with these cool colors.

The neutral scheme is without a doubt one of the most beautiful because of its wonderful harmony. It is an easy procedure to use a color with its direct complement, modifying the proportions. Two pairs of complementary colors can form part of this method for developing two neutral ranges or schemes.

A neutral color scheme can have a warm feeling.

A neutral scheme can show cool tendencies.

MORE ON THIS SUBJECT

- Color Theory for Ink **p. 62**
- Direct Mixing **p. 66**
- Contrast Between Colors and Tones **p. 70**

TECHNIQUES AND PRACTICE

THE THREE PALETTES

By developing the three general color schemes, we are working with the possibilities of a warm, cool, or neutral palette, depending on the color feeling that the drawing needs to convey, using both the brush and the dip pen.

Hints from the Model

The model suggests the type of colors that need to be used and the general feeling that the mixtures must convey.

The model that is chosen for the drawing may clearly suggest the palette that needs to be used. For example, a case where the color tendency is warm can be approached from the three primary colors: yel-

The schemes are created based on yellow and carmine, and on carmine and blue.

Working with a dominant warm color does not exclude the possibility of using a cool color to create contrast.

low, carmine, and blue. However, all mixtures will be created keeping in mind the predominance of warm secondary and tertiary colors, and the creation of neutral colors that also have a warm undertone.

These samples of mixtures reveal the use of each primary color, even in the mixtures for neutral colors.

A Cool Tendency

A landscape theme with a sky and meadows is one of the most appropriate subjects for a cool palette. Cloudy days suggest neutral grays, whereas the night sky calls for cool blues and violets. Undiluted cool colors are very dark and must be handled with caution, whether a brush or a dip pen is used. The wash is, of course, the technique that best creates more diluted tones of a delicate effect.

This charming work was created by mixing only the three primary colors, yellow, carmine, and blue, to create a warm palette.

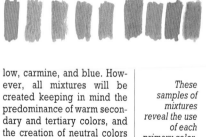

A cool landscape with greens and blues requires basically a cool palette.

Contrast Between Color Schemes

To create a good contrast between the different planes in the picture representation, two different complete color schemes can be used, or one scheme and one color, etc. The possibilities are endless.

A cool color contrasts with a warm scheme. A warm color contrasts with a cool one. A warm or cool scheme of pure colors contrasts with a neutral one. A subtle contrast can be obtained with a cool neutral scheme and a warm neutral one.

A small neutral scheme can be created with just two colors, sienna and ultramarine blue, overlaying wet on dry.

The Neutral Palette: Warm and Cool

The range of neutral colors is extensive, and as a general rule, it is not used in its entirely in one single drawing. It is very common to work on a project from beginning to end with a neutral palette that is obviously warm or obviously cool. For example, a warm neutral palette usually accompanies a warm palette because all the earth colors and green create mixtures that are compatible with that scheme.

The grays have a neutral tendency, and they can be created by mixing almost equal parts of any two colors that form a pair of complementary colors.

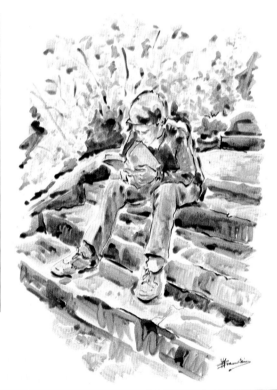

A work in which M. Braunstein has developed a warm neutral ink palette based on sienna and sepia.

OVERLAYING WASHES

The order for overlaying washes follows the rule that the lightest color should be applied first, continuing with the increasingly darker colors. This is the way to achieve the most luminous results while using the most convenient techniques for each effect.

The Wet-on-Dry Technique

Mixing colors by overlaying them is done with the wet-on-dry technique. A darker color is created by laying same color tones one over the other, or two different tones of the same color, always applying them wet on dry.

Inks dry rather quickly, although the time depends on the characteristics of the paper and on any additives that they may contain. Ink, therefore, is a good medium for overlaying under normal conditions.

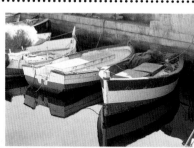

A group of boats tied to the dock can serve as a model.

The sketch is drawn with a watercolor pencil, which will dilute when the wash is applied.

The Order of the Washes

The traditional luminosity of ink is maintained if the lightest wash is applied first. When a layer is completely dry, the second wash, which will be darker, is applied. The dry ink being indelible, does not mix at all with the second wash. The overlay stays clean, and the luminosity of the ink that was applied first lightens the color o

The first washes are applied with very diluted ink, reserving the white areas.

The washes become gradually denser while the first mixtures are applied with the overlay technique.

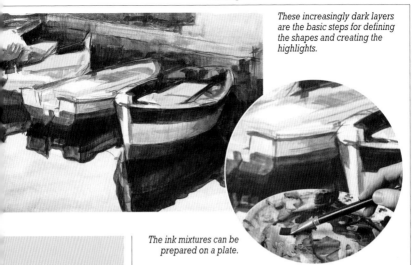

These increasingly dark layers are the basic steps for defining the shapes and creating the highlights.

The ink mixtures can be prepared on a plate.

An Approach to Color

An ink project that is to be carried out with washes requires careful color planning. The artist must visualize the different washes that will be used, which will be planned keeping in mind the rule of dark over light. Small tests should be carried out on scrap paper to ascertain the effects of overlaying. At the moment of truth, the preliminary work will prove to have been useful and necessary for avoiding corrections.

Ink is a very luminous medium when it is wet, but darkens when it dries. In planning the general approach, this quality must be kept in mind when deciding which tone for each layer will produce the most suggestive and attractive results.

the second wash. The same thing happens with any subsequent washes.

This procedure is carried out whether applying washes of different colors or a wash of the same color but a different tone. In the case of same-color overlaying, the lightest and softest wash is applied first.

MORE ON THIS SUBJECT
• Gradation Techniques **p. 60**

The Middle Ground and Background Washes

Middle and distant planes require very light washes that contain a good amount of water. The drying time varies, depending on whether the paper has been previously dampened with water, and on the degree of absorbency of the paper. These conditions favor the creation of these planes with the wet-on-semidry technique. Working in this manner, the lesser degree of contrast that these planes require is immediately achieved.

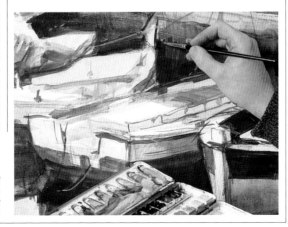

Some details are finished with watercolors to soften the characteristic harshness of the ink.

VARIEGATED AND GRADED WASHES

The two most common techniques when using two colors are one that produces variegated strokes of color, and one that allows the creation of gradations.
The fluidity of the ink is a vital factor in both cases, as is the motion of the brush, which must be quick and decisive.

The Variegated Wash

The effect created by mixing two colors directly on the paper while they are wet is said to be variegated, because the resulting color is not consistent all the way through.

This subject matter suggests a cool palette, with some warm colors for contrasting details.

On the contrary, the area displays a veining effect of one color within the other.

Variegated washes are normally used to represent the most distant planes, like clouds. Other subjects, like the ocean or a river, need to depict the movement of the water, and this type of wash can be appropriate for that. A variegated wash can also be alternated with mixed techniques, which provide more credibility to the drawing. Using

The sketch is done with a blue watercolor pencil.

When the wash is applied, the pigment of the watercolor pencil mixes with it. This creates beautiful variegated effects.

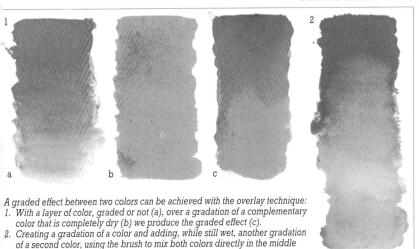

A graded effect between two colors can be achieved with the overlay technique:
1. With a layer of color, graded or not (a), over a gradation of a complementary color that is completely dry (b) we produce the graded effect (c).
2. Creating a gradation of a color and adding, while still wet, another gradation of a second color, using the brush to mix both colors directly in the middle area.

watercolor pencils or water-based markers can quickly produce the required textures.

Gradations Between Two Colors

A gradation between two ink colors can be very luminous, because of the quality of the ink and the luminosity of its transparency. A tonal value created from a two-color gradation is used by reserving the lightest area of the gradation to represent the areas of light, and the darkest for the areas of shadow.

Grading by Overlaying

If the gradation is created with an overlay technique of wet on dry, the lightest color should be applied first. The second color is applied only after the first one is dry. Because dry ink is indelible, the second layer will not mix at all with the first one. This is why two-color ink gradations are so clean and bright.

Wet Gradations

When two colors are graded wet on wet, it is advisable to give preference to the lightest color over the darkest. The brush movement for creating the gradation must be very quick, so that both inks remain wet. The brushing motion also must be complete, to create a subtle gradation without color gaps.

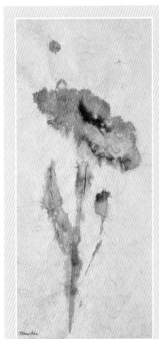

The Paper and Variegated Color

The characteristic of the sizing on a paper like *fancy silk* absorbs the ink and creates multiple colored filaments. In this case, the variegated color produces a veining effect, which has great artistic value. A paper of these characteristics can also be dampened beforehand to enhance the richness of the variegated effect.

The area of the flower in this fancy silk paper is wetted before painting. M. Braunstein used only two colored inks, applied wet on wet, to create these interesting variegated effects.

TEXTURE EFFECTS

The brush is an exceptional tool that is easily able to lay down different textures. These can be used to create a variety of contrasts that will contribute to very artistic results. The dry-brush technique, for example, allows the creation of light and blurred tones.

The Appropriate Contrast

India ink is a medium that requires special care to prevent the drawing from ending up looking too dark. The only manner of shading without washes and without making dark blocks of color with the brush is the dry-brush technique, which produces a range of tones.

Dry Brush

The dry-brush technique is based on the use of a clean, dry brush to which a little bit of ink, barely a drop, has been added. When this brush is rubbed on the paper, it leaves very faint marks. The dragging action dries the brush, and the process must then be repeated. Shapes are modeled with the dry-brush technique by using a square brush at all possible angles. The brush stroke can be a straight line to draw fields in a landscape, or a cir-

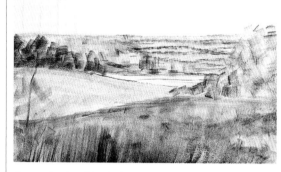

A square brush and the dry-brush technique are used to create the foundation of the drawing. Each texture can be made by applying the brush strokes in the appropriate direction.

cular or zigzag motion to represent the most undefined vegetation.

MORE ON THIS SUBJECT
• Printing Effects **p. 82**
• Other Mixed Techniques **p. 94**

Dry Brush and the Solid Brush Stroke

It is easy to create contrast between the light, tenuous and indefinite dry brush, and the full-blown brush stroke. A landscape, a still life, or a figure can be painted without difficulty using these two tech-

A square brush, with a little more ink, adds texture to the base drawing by representing the vegetation.

A thin brush is good for applying the details of the foreground.

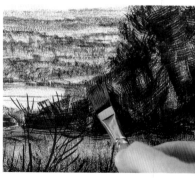

Scratching

Another method for shading without creating such dark effects consists of using a type of paper or board that, once covered with ink, can be scratched to expose white areas.

The subject matter will dictate whether to begin with a paper that is completely covered with ink or just partially covered. In either case, the surface of the drawing can be scratched, and by exposing white areas, it acquires a notably lighter appearance.

Scratching also allows the creation of textures that would be impossible to make with any other tool that is not as sharp as a blade.

When the ink is scratched off, it is recommended not to go down as far as the surface of the paper. Be careful to remove just the ink, as if flaking it off.

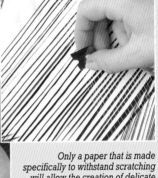

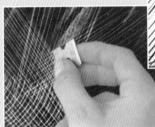

The surface of a special paper that will withstand scratching can be completely covered with ink. When the ink dries, texture can be created with the scratching technique.

Only a paper that is made specifically to withstand scratching will allow the creation of delicate textures with a blade that would otherwise be impossible to make.

niques correctly. The faintest dry brush is used to represent elements in the distance. A darker and more vigorous dry brush is appropriate for defining objects in closer proximity. Finally, ink brush strokes provide the greatest contrast for representing the closest and most relevant plane.

The differences between the delicate texture of the sky, the middle ground, and the closest plane are clearly defined.

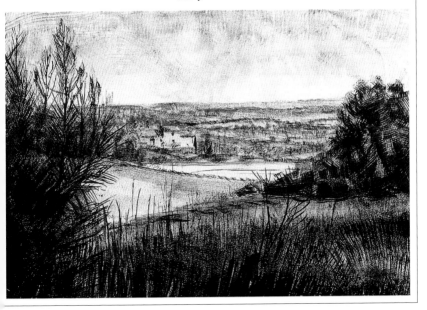

PRINTING EFFECTS

Ink can be applied using the printmaking process. Among other options, the technique that requires a sheet of linoleum, gouges, an ink roller, and a rolling pin is very affordable, although it is essential to spend a certain amount of time learning the process.

The Impression

Any object that is covered with ink can leave an impression on paper. This impression must be created with some control to be able to use it with drawing. A simple exercise that is learned in elementary school consists of folding a piece of paper that has been covered with ink. The wet spot spreads over the blank area, forming whimsical shapes.

Printmaking with Linoleum

A piece of linoleum is cut in accordance to the size of the paper. A white pencil is used to make what would be a sketch of the model, keeping in mind that the impression will be a reverse print of the image.

The linoleum is carved carefully, using the appropriate gouges. Remember that the areas that are removed will not leave an impression. The dif-

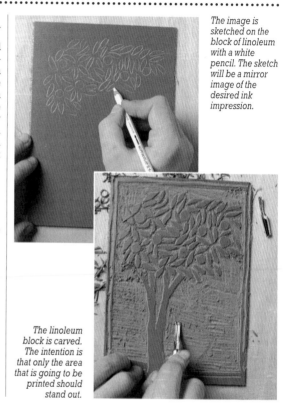

The image is sketched on the block of linoleum with a white pencil. The sketch will be a mirror image of the desired ink impression.

The linoleum block is carved. The intention is that only the area that is going to be printed should stand out.

The ink must be evenly applied with the roller.

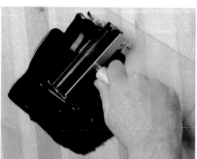

Ink is applied to the piece of linoleum with the roller, being careful not to ink the areas that have been cut out.

ferences of the heights of the surface must be well defined to avoid rolling the ink on the areas that have been cut out. This way the printing roller will not cause the paper to make contact with ink on a lower surface and ruin the print.

Ink is applied to the linoleum with a roller that has previously been covered with ink. The ink should be spread evenly while being careful not to miss any high areas.

The linoleum is then carefully placed facedown, exactly centered on the paper. It is important to work quickly but carefully. Firm pressure is applied with the rolling pin, being careful not to miss any areas.

The linoleum is placed facedown, exactly centered. A rolling pin can be used to apply pressure.

Handling the Linoleum

Extreme care must be taken when the linoleum is placed over the paper and when it is removed from it. Ink should not be dripping from the piece of linoleum at this stage; therefore it should not be overinked, and the linoleum should remain as horizontal as possible when the block is turned over so the ink does not flow.

To place the block over the paper, the two lower corners of the future print are established as reference points and are matched with those of the sheet of linoleum. Then, with a steady motion, the block is applied, pressing from these contact points until the linoleum is flat over the paper. Finally, pressure is applied with the roller.

To remove the linoleum, one of its corners is lifted with one hand while holding the bottom with the other. Continue lifting it until it can be comfortably held and is no longer in contact with the paper.

The final ink impression is an inverted and positive image of the drawing carved in linoleum.

When the linoleum is removed, it will leave an impression of the drawing on the paper. You will notice that it is the mirror image of the sketch carved in the linoleum.

Various Texture Effects

Many different printing effects can be created. The characteristics of papers that have a distinct texture, like a grid or grooves, can be used to add drama to the drawing.

Different textures can be created by printing, using a cotton screen, corrugated cardboard, and a simple ink blot made by folding a sheet of paper.

There is always an element of freshness because of the spontaneity of making this type of image. An imaginary landscape can be represented using the contrast between the lines in corrugated cardboard and the weave of a piece of cotton screen.

VARIOUS EFFECTS

The drawing tool that is used, the procedure, the technique, and the interpretation are
variables that give a work of art its uniqueness.
The possibilities are great, and it is worth mentioning some special aspects
for their notable effects.

Pointillism

Pointillism is, without a doubt, the simplest system for creating an artistic representation. The most useful sketch is lightly drawn with a pencil, being sure to include many details and a complete tonal range.

Pointillism is based on the idea of reserving the white color of the paper for the parts with most intense light and reflections, and of creating areas of increased density of dots per unit of surface to represent the progression of shadows.

In this case, the secret is the tool chosen, a technical pen with a tubular tip, which makes the pointillism technique easier.

Light and Shadow with Scribbles

A trivial element such as scribbles—in other words, irregular and whimsical shapes drawn to mimic letters and scraps of writing—can be an effective method of shading. The criterion to follow is that the white color of the paper corresponds to the areas with the most intense light; as the intensity of the scribbles increases, so does the progression toward the darker areas of the drawing.

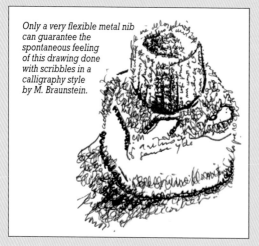

Only a very flexible metal nib can guarantee the spontaneous feeling of this drawing done with scribbles in a calligraphy style by M. Braunstein.

The difficulty of this technique resides in the need to draw dots of the same size. However, in some cases, different-sized dots can be used, saving the heavier ones for the darker areas.

The ink must be completely dry to be able to safely erase the pencil lines of the sketch.

Shading with Perspective

This type of shading is effective and requires very few elements: the outline drawing and parallel lines for shading. But it is necessary to have a solid foundation in perspective

MORE ON THIS SUBJECT

- Contrast Between Colors and Tones **p. 70**
- Variegated and Graded Washes **p. 78**
- Printing Effects **p. 82**
- Other Mixed Techniques **p. 94**

A knowledge of perspective drawing is necessary in this project, because that is what dictates the direction of the series of lines.

feeling is delicate and devoid of harshness.

The line, in contrast to this dry-brush technique, is clean and fine, and perfectly depicts the shapes.

An example of pointillism in which the size of the dots progressively increases.

drawing to create this type of shading. The vanishing points dictate the direction of the parallel lines.

Dry Brush and Lines

The dry-brush technique is used for modeling. The texture is created by using a small amount of ink, barely enough of it to color a brush that is clean and dry, and by dragging the bristles on the paper, which is dry as well. This effect strongly contrasts with the strokes of the line drawing.

Light and shadow are created by dragging a dry-brush over the paper. This is the extent of the tonal work needed to give the drawing the perception of depth. The general

A work like this one requires heavy-grain watercolor paper. First, a foundation is created using the dry-brush technique, and then the shapes are blocked in with the line technique using a dip pen.

THE METHOD

An ink drawing is not approached randomly. The different procedures must be applied in a certain order. Before beginning to draw, it is important to plan all the steps that are involved regarding the different planes: distant, middle, and near.

Planning

Every step must be carefully planned when deciding how to represent the model. Preliminary sketches, color tests, and written notes are useful for this purpose. And when the technique involved is a wash, the artist must always remember to apply dark over light.

The Method for Monochromatic Drawings

The simplest drawing that can be executed with undiluted ink is done with a fountain pen. The continuous supply of

All the elements should be well defined on paper before the project begins. A drawing always begins by working the most distant plane and the background.

ink makes drawing lines much easier, and the artist simply needs to pay attention to perspective and proportions.

In this case, the drawing always progresses from the distant plane to the closest one.

Therefore, defining the features of each plane is essential to be able to differentiate them properly. A project created with a reed or dip pen requires constant charging. Following the general practice, it is also a

Proceeding in order, the drawing is made working from the most distant plane, to the intermediate, to the closest.

The ink line is heavier as the artist reaches the closest planes of the drawing.

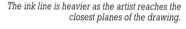

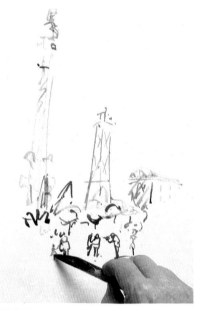

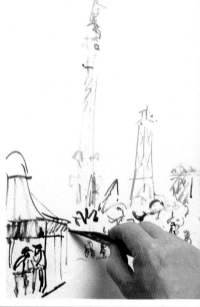

The closest plane is the one with the most contrast and also the one that is worked last.

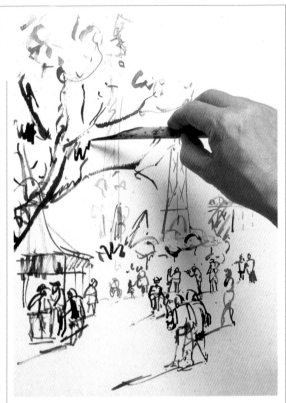

Removing the Masking

The protective frame is removed at the end of the project, when the wash is completely dry.

The liquid resist and the areas reserved with templates or gummed paper within the drawing are removed upon completion of the work, or when there is danger to the reserved areas. A resist can be useful for one wash, but may not be necessary for the next.

matter of planning the types of lines that are going to be drawn based on the amount of ink each tool is able to carry.

Creating the Foundation

A good foundation for the drawing is one that defines all the elements of the representation without too many lines, and leaves the background finished. This base must be completely dry before the next overall layer is applied.

The vagueness and level of synthesis of the far plane sets the tone for a more detailed working of the next plane, and so on, up to the most defined work of the nearest plane.

Reserved Areas First

When working with ink, the reserved areas are located mentally, and drawing in them is avoided. When painting with washes, on the other hand, it is very important to situate the reserves before the work begins. A safety border is defined around the four sides. Gummed paper, tape, liquid resist, or white wax is used for reserving areas. It may be necessary to use a sketch to help place the reserves.

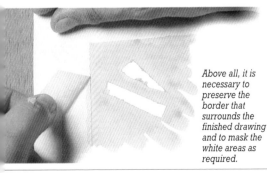

Above all, it is necessary to preserve the border that surrounds the finished drawing and to mask the white areas as required.

White wax is used before proceeding with the wash to mask reserves with a blurred edge.

LESSONS FROM THE MASTERS

The main characteristics of the traditional ink drawing are based on the use of soft washes with few colors, and the use of lines to describe shapes, proximity, and distance.
These same characteristics remain important to this day, and they continue to be used as illustration techniques.

Traditional Washes

Washes tend to be even, with a single application in each separate area. However, artists may also use some graded washes, especially to represent the sky. A generous amount of water is added to the ink to create very light tones. The washes barely add color to the drawing, but they give it a delicate hint of the color.

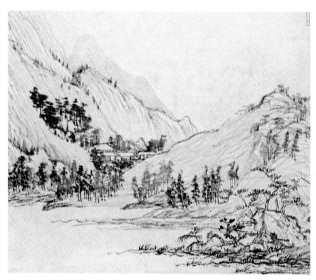

Huang Kong-wang. Houses in the Fou-tch'ouen Mountains. Section of a horizontal scroll. Ink on paper. From the collection of the Taichung Palace (Taiwan).

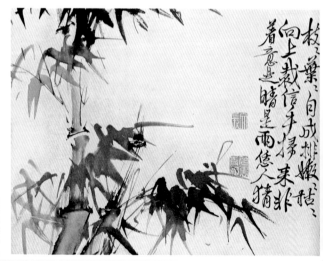

Su Wei. Bamboo. Section of a horizontal scroll. Ink on paper. Freer Gallery of Art (Washington, D.C.).

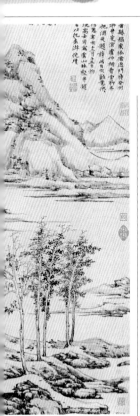

Ni Tsan. Trees on the Valley of the Yu-Chan River. *Vertical scroll. Ink on paper. From the C. C. Wang collection (New York).*

mixtures on paper. Therefore volume is expressed with the contours and with the correct application of perspective and proportions.

The Difficulties of Washes

The difficulties in this type of printing rest mainly in achieving a flat wash, and in staying within the boundaries when applying it. To color a particular zone, the artist must wait for the surrounding areas to dry out completely.

The Brush Stroke

The most artistic expression can be found in the common themes of Chinese and Japanese traditions. Bamboo is a very common plant in those countries, and also one of the most widely represented. It cannot be denied that drawing bamboo enables the artist to develop a series of artistic brush strokes. Landscapes without an aggressive foreground cannot

Expressing Volume

One of the characteristics of traditional Chinese washes is the absence of overlaying or direct

compete with this fluidity and resolve.

Line Work

Landscapes are one of the preferred subjects of Oriental washes. The scenes represent buildings, vegetation, rivers, lakes, rocks, clouds, mountains . . . Lines describe the shapes and synthesize them perfectly, whether on intermediate planes or in the background. These lines are based on a profound knowledge of drawing, supported by an essential sense of synthesis that prevents the work from looking harsh.

Another Component

Calligraphy, normally done with a brush, almost always forms part of traditional Chinese and Japanese washes, which are very closely linked to religious themes. The artistic quality of the calligraphy is surprising for the differences that exist from one artist to another. Master Su Wei makes magnificent artistic calligraphy.

Lou-Tche. Autumn Colors in Siun-yang. *Section of a horizontal scroll. Ink and light colors on paper. Freer Gallery of Art (Washington, D.C.).*

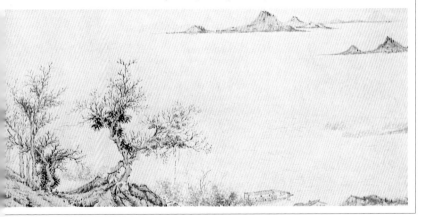

THE SUMI-E LESSON

The basics of the Sumi-e technique can be applied to any work of art made using either ink washes or watercolors that incorporate a limited number of colors.
The way the special brush is held when applying this technique is very useful to know.

• •

The Brush, the Ink, the Paper

The brush must be made of bamboo and deer, goat, or boar's hair. The reed is 7 inches (18 cm) long by 3/8 inch (10 mm) in diameter.

The ink stick is diluted and prepared on a rectangular plate called a *suzuri* (a stone for ink, in Japanese), which has a well at one end. A portion of the ink stick is scraped or ground on the *suzuri*, which has a surface similar to a piece of sandpaper. The particles of pine tree charcoal or lampblack and the binder fall into the well of the *suzuri*, which has previously been filled with water. Once the work is completed, the *suzuri* must be washed with clean water to leave the surface ready for scraping, and to avoid mixing new ink with a previous ink that has already dried.

How to hold the brush for a Japanese wash.

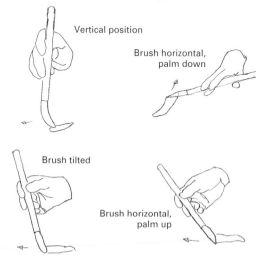

Vertical position

Brush horizontal, palm down

Brush tilted

Brush horizontal, palm up

How to Hold the Brush

The brush used to make Japanese washes is held at different angles, which are unusual from the standpoint of Western brushes.

The Japanese brush is held perpendicular to the paper for firm, straight brush strokes. A tilted position is used for wide marking lines, to draw thick borders, or for shading large surfaces.

The widest lines are created by holding the brush horizontally, practically parallel to the paper. The thick handle of the Japanese brush favors this hand position, with the palm facing up or down.

The wash technique with watercolors always starts with the lightest wash, which is normally reserved for the background.

The color of the wash gradually acquires more intensity using the wet-on-wet technique, moving progressively toward wet on semidry.

An overall gradation guarantees the correct perception of depth.

The technique of wet on semidry or on dry is used to apply the different washes to create the planes working toward the foreground.

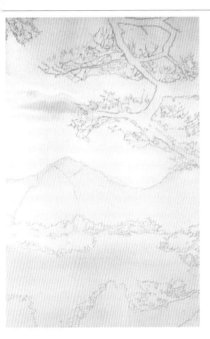

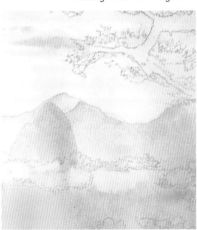

An Instant Gradation

The brush is held vertically to charge it with ink. More color is concentrated at the tip, and there is a greater amount of water and less pigment toward the handle. One of the consequences of this is that when the brush is held horizontally, the paper can be colored with a directly applied gradation.

Paper for Sumi-e

The paper for Sumi-e must have very little sizing so that it can absorb the dampness of the brush. Rice paper, the most commonly used in Japan, is available in sheets. This type of paper requires a felt underneath to absorb the excess water.

Other types of papers can also be used, although the effect of the washes or brush strokes will have a different finish. Any type of paper that is porous and has a rough surface and little sizing can also be used. In fact, any normal drawing paper is perfectly suitable for practicing.

The foreground is created with dark ink on dry. This guarantees a strong contrast of color, tone, and definition.

MIXED TECHNIQUES FOR LINES

One of the most common mixed techniques consists of using India or colored ink for the contour lines and watercolor or washes for the ground. The use of more or fewer contour lines depends as much on the artist's interpretation as on the kind of illustration.

The World of Illustration

Many artists and illustrators of textbooks and children's books favor the mixed technique for its interesting results. The drawings can be small in size, as required by the vignettes and book formats. The paint or color provides the volume, and the lines, which can be very thin if drawn with a dip pen, describe all the fine details.

The contour drawing must suggest all the motion for the action.

Creating the Ground

Watercolor paints and ink washes are used in light tones to give the work a luminous effect. For children's illustrations, washes tend to define areas and are evenly applied. The difficulty of painting with colors is producing flat washes that stay within the boundaries of each area.

Profiles in Synthesis

The features of a face, as an example, are colored with a flat flesh tone, and a few simple lines are enough to define some details. In illustrations that do not have gradations of light and shadow, expressing

Working over Watercolors

Drawing with undiluted ink over a watercolor ground is a risky undertaking. Very high quality paper must be used to withstand the wash and to maintain its characteristics and sharp defined lines when it dries. It must always be assumed that the ink will mix a little with the watercolors, even when they are dry. This diminishes the brilliance and purity of the ink's color.

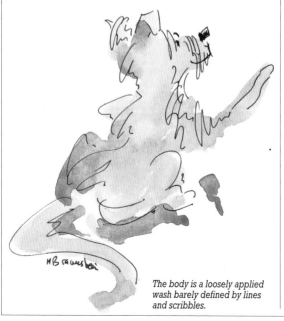

The body is a loosely applied wash barely defined by lines and scribbles.

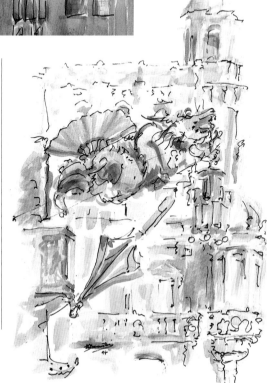

In a night landscape, the contrast provided by the line technique must correspond to the overall tone of the wash.

The Line Work First

Some illustrators prefer to work in the opposite manner. First, they draw the lines with all the details. Then, when the lines are completely dry, they proceed to color the various areas of the drawing, which are perfectly defined within the indelible lines. When the wash is laid over the drawing, the ink loses its shininess. Therefore, if doing the line work first, the artist must have complete control of the wash process, whether it is applied with ink or watercolors.

movement or a gesture can be achieved only with accurate drawing and dramatic line work.

The Color First

In general, artists begin by laying down the color over a few, lightly drawn pencil lines that constitute the sketch. When this application is completely dry, the corresponding outlines and contours are drawn using a dip pen or a technical pen with a round tip, and India or colored ink.

The line work must support the interpretation of the subject. Drawing by M. Braunstein.

OTHER MIXED TECHNIQUES

Ink is suitable for use with various mixed techniques. Washes are compatible with other water-based media like watercolors, watercolor pencils, or water-based markers.

All Water-Based Media

Since ink is a water-based medium, it may be alternated with all the other media that are water soluble. The techniques that can be used if the different media are combined depend on the characteristics of each one.

The basis of this work consists of a sketch done with a blue watercolor pencil and an ink wash. Texture is applied to these forms by drawing over this foundation with water-soluble markers.

imperfections in large washes. Common, nonsoluble colored pencils are used for finishing, keeping in mind that once applied, they act as a resist for the ink.

A few more details are added with markers, reinforcing aspects of the drawing to convey drama. Drawing by Miquel Ferrón.

Successive washes mix markers and ink.

Watercolor Pencils

The sketch for the wash is created with a watercolor pencil. The pigment of the pencil and the ink are mixed directly on the paper.

But watercolor pencils can also be incorporated later, when the ink work is finished and completely dry. This is a very common practice among artists, who do this to touch up the small details or blend

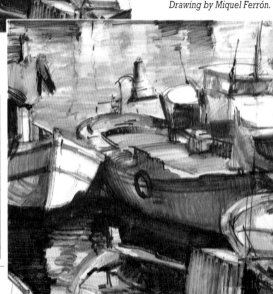

Water-Based Markers

Water-based markers can be alternated with ink. If markers are used first, their colors will blend with those of the ink wash if they are still wet. However, for the opposite procedure, using them over an ink wash, the paper must be completely dry before the markers are applied. Otherwise, there is a chance of damaging the paper.

Hatching created with water-based markers does not blend completely when it is treated as a watercolor. The texture effect shows less contrast than when a reed pen or a dip pen is used. Water-based markers require a watercolor paper that will withstand the water but that is easy to draw on.

Ink and Waxes

Ink together with waxes can produce original results. Wax is an oily medium that repels ink and acts as a resist.

White wax can be considered a resist, meaning that it can keep the paper free of ink. It is not as effective as a piece of cardboard, a template, or masking liquid, because where the layer of wax is not very thick, there are always small drops of ink that soak into the paper. But the texture effect is original and interesting and worth keeping in mind.

Colored waxes become part of the drawing, adding the power of their color to the luminosity of the ink.

Wax can easily be scratched to create a sgraffito, adding another texture that enriches the work by restoring white areas with or without hatching.

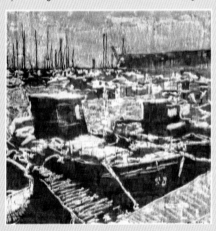

This original seascape was created by M. Braunstein with white wax resists and different tones of India ink diluted in water.

Wax allows using sgraffito to create highlights and to enrich the texture.

The effect of the mixed technique using colored waxes and inks depends on the surface and the quality of the paper: 1. on smooth paper, 2. on heavy grain paper.

All inquiries should be addressed to:
Barron's Educational Series, Inc.
250 Wireless Boulevard
Hauppauge, NY 11788
www.barronseduc.com

International Standard Book No. 0-7641-5699-3

Library of Congress Catalog Card No. 2003103387

Printed in Spain
9 8 7 6 5 4 3 2 1

This collection includes four series:
RED SERIES: Artistic Subjects
BLUE SERIES: Techniques
GREEN SERIES: Various Subjects
YELLOW SERIES: History of Painting

Note: The headings at the top of odd pages correspond to:
Title of the previous subject
Title of the present subject
Title of the following subject